AFTER THE OFF

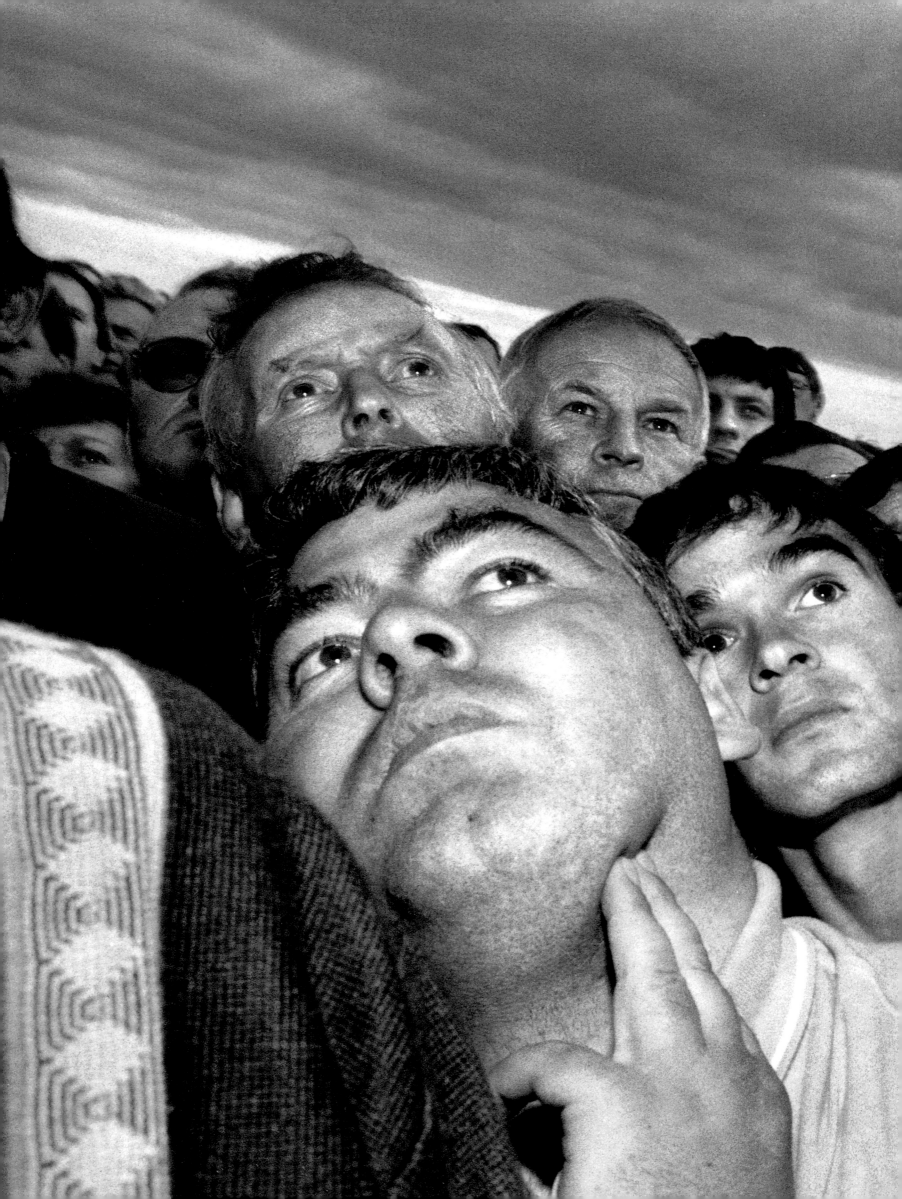

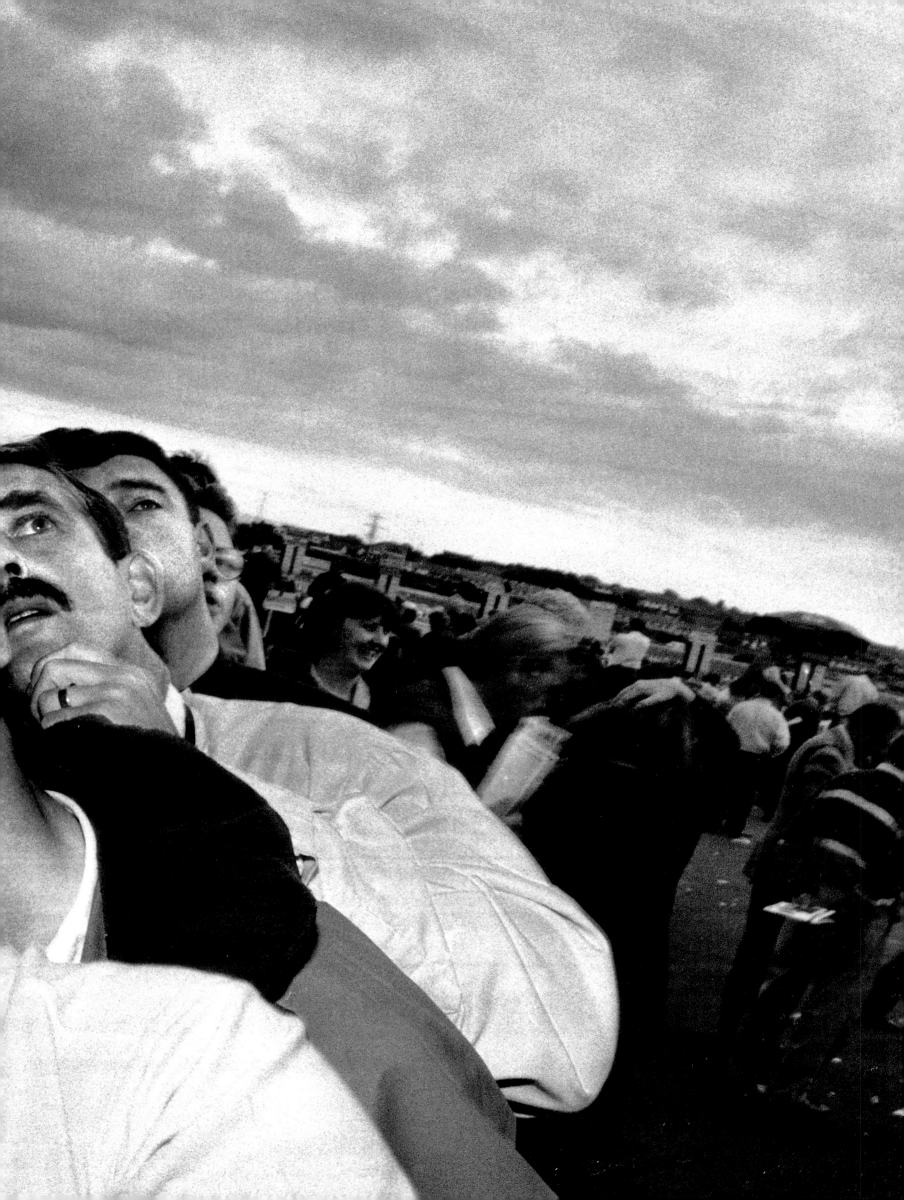

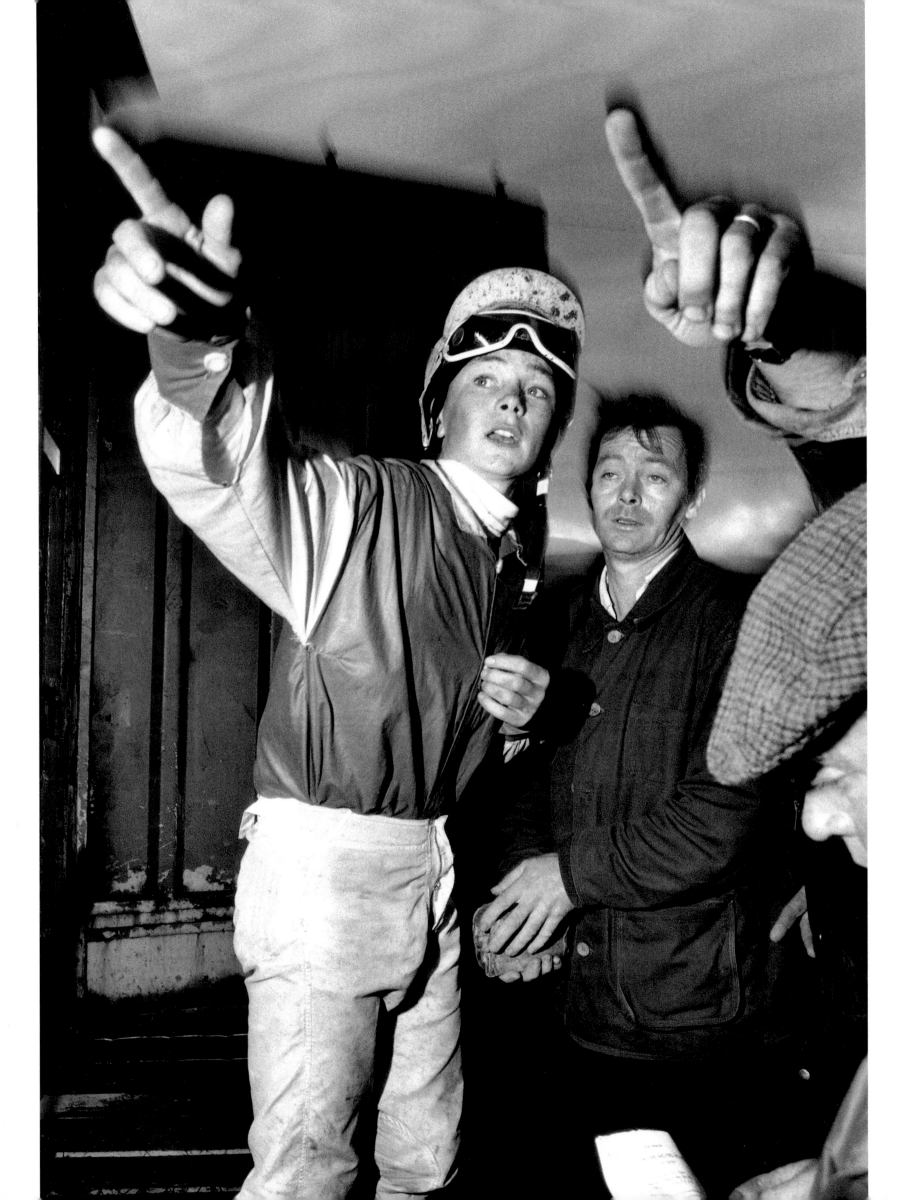

AFTER THE OFF
PHOTOGRAPHS BY BRUCE GILDEN

SHORT STORY BY DERMOT HEALY

DEWI LEWIS PUBLISHING

before the off

From early morning beasts and men were trecking in from the mountains. The townsfolk came out their gates like they were going to a wedding party. The bank girls went to work with a change of clothes for the half-day. Ladies pinned extraordinary hats to their scalps and stood back from the mirror a moment. Stalls went up in the market yard, Eliza Satins were spread, work boots travelled out to the course in Hiace vans. Tarpaulins shot across pressed, second-hand suits, camouflage jackets were pegged to washing lines, wellingtons were arranged in neat lines.

Gamblers, who had missed breakfast below, woke in a room where a poker game had ended only hours before. The 3-card trick man sat in his B & B doodling on the menu. An assistant trainer walked a lone horse along the strand. From the island the barnacle geese rose as one and flew to the mainland. **Chattering madly they landed on the goose meadow by the bay.**

Extra newspapers were dumped into the entrance of Cullen's shop. Matt Sheridan came out the back door of the Irish House Hotel, went up the town, selected an Irish Independent and tossed a poin coin on the pile of newspapers. He stopped in the middle of the street and turned to the racing pages. **Phew!** he said to himself. This dog came up the town and lay down by the monument. A loud speaker shrieked to itself on the racecourse. The cattle milled into the mart that would end at one in time for everyone to be at the races by two. Testing, said a voice.

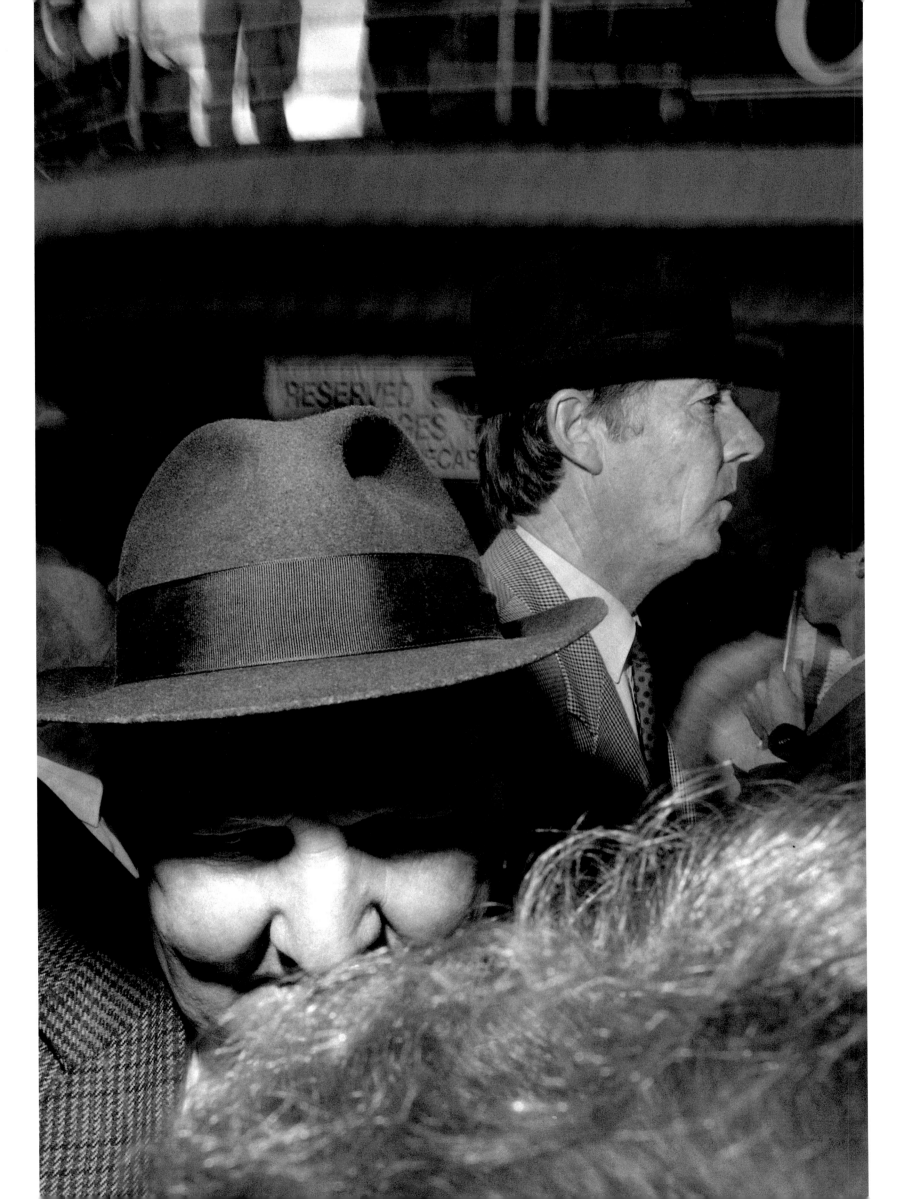

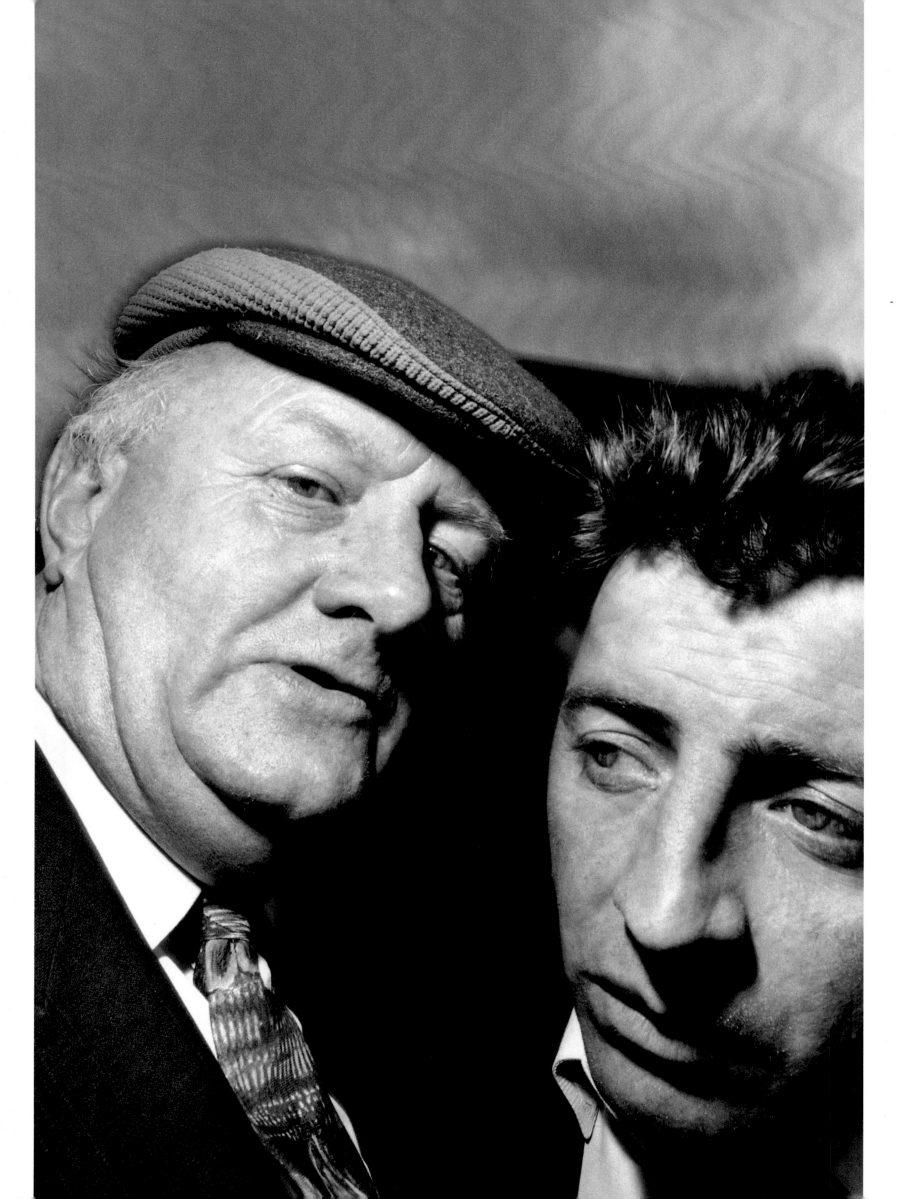

Testing, it said as Aggie Lang opened the back door of the pub to Murphy.

He shook the dew off his coat and went to the toilet. Tim Pat came in.

It's a pet day, he said, for the ponies.

It is.

Is Murphy here?

He' be out the back.

Fuck him.

Are ye arguing again, asked Annie.

He is. He thinks I told the guards that he was carting stones off the beach.

And did ya?

I did not not.

Well then, said Aggie, your conscience is clear, isn't it.

I suppose, he said. But then Mrs, is it ever?

He went behind the bar and changed a barrel of Guiness. He swept up after the night before. Then Tim Pat went back onto the street to watch the horse boxes arriving. He strolled over to the vendors and tried on a straw hat. He looked into a wellington boot. He studied Langs. Aggie was lighting the fire when Murphy returned with a bucket of turf from the yard. There you are M'am, he said, then sat on a high stool waiting while she made herself tea within.

They're going to build a ring road round the town, he shouted.

They'd never, called Aggie.

It's in the paper, he said.

I'm sure.

Tim Pat came across the street again. He stood against the gable of the pub. Fuck him, he said again, and pushed in the back door. Murphy coughed ironically. The two men looked at each other with dismay.

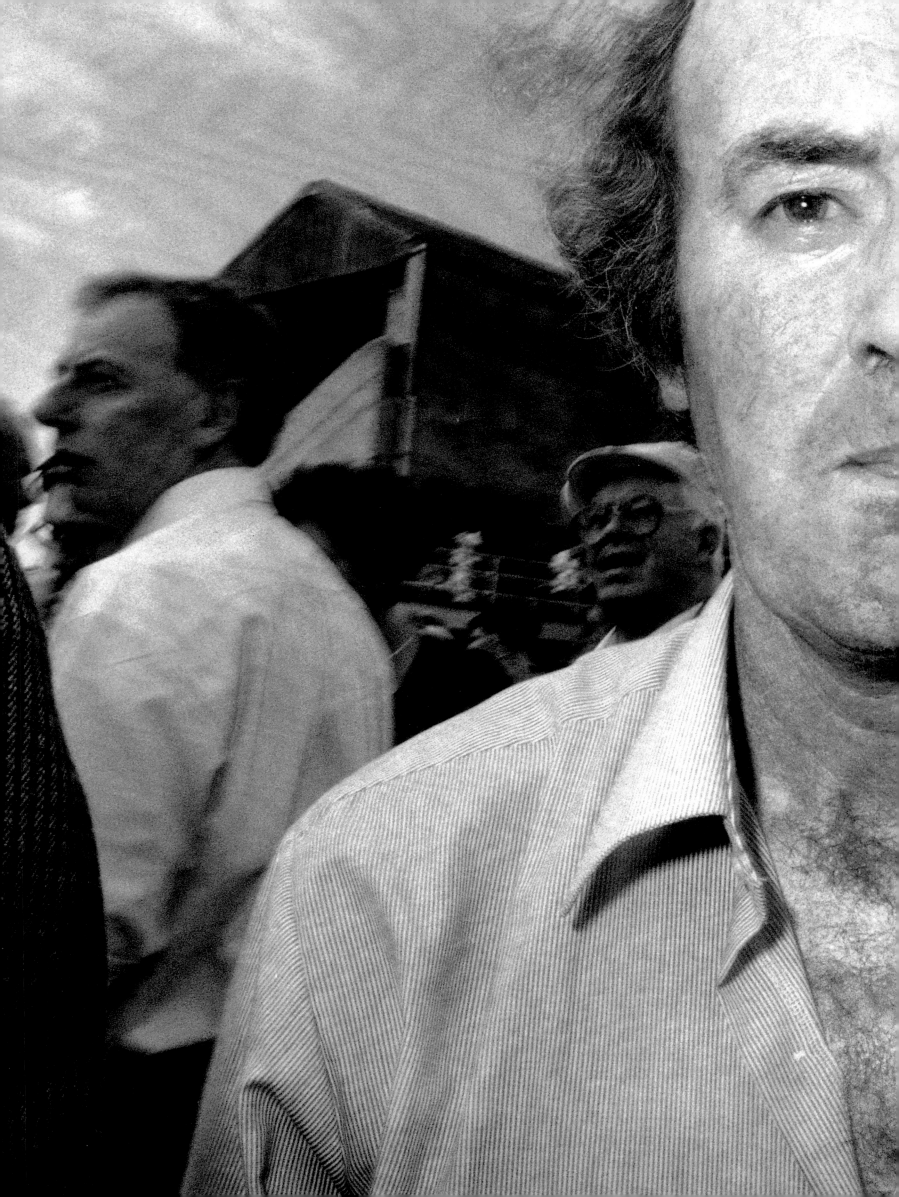

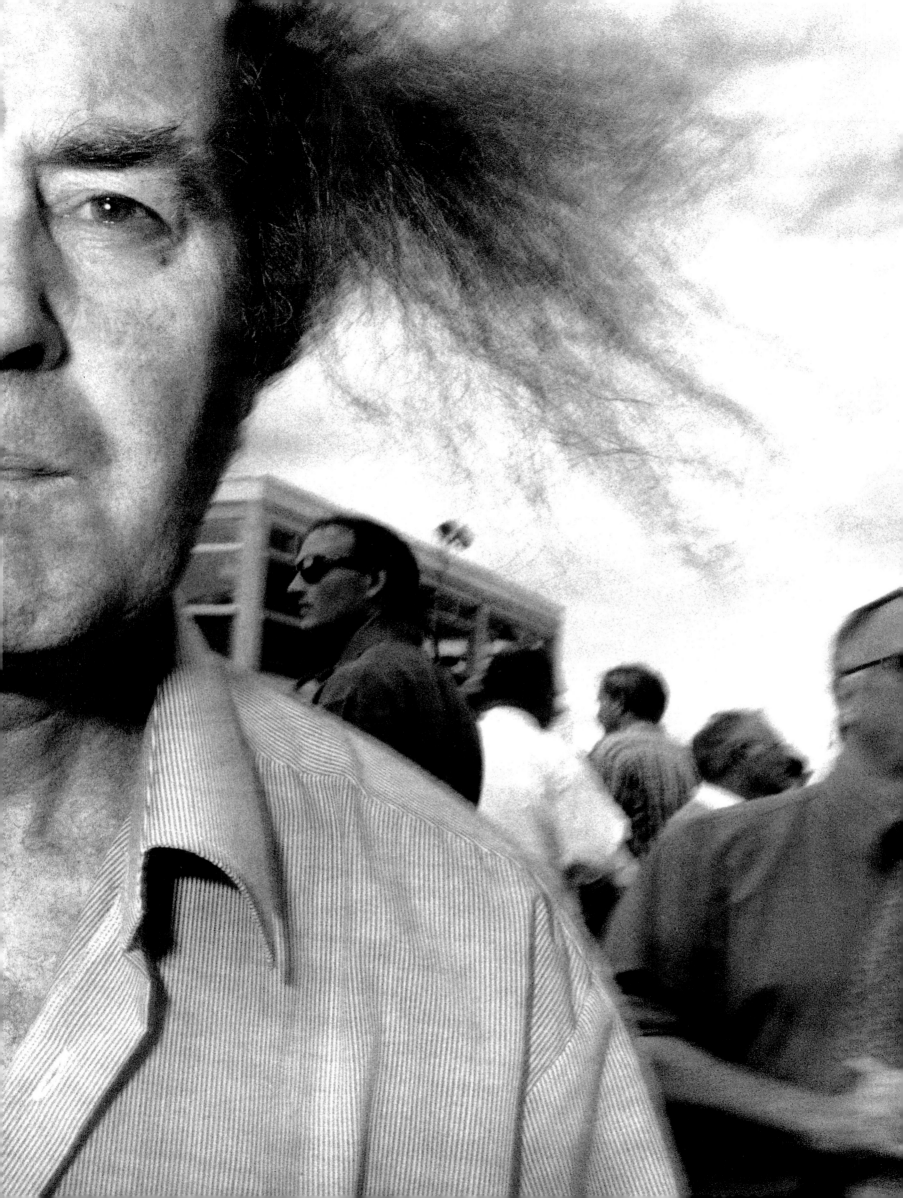

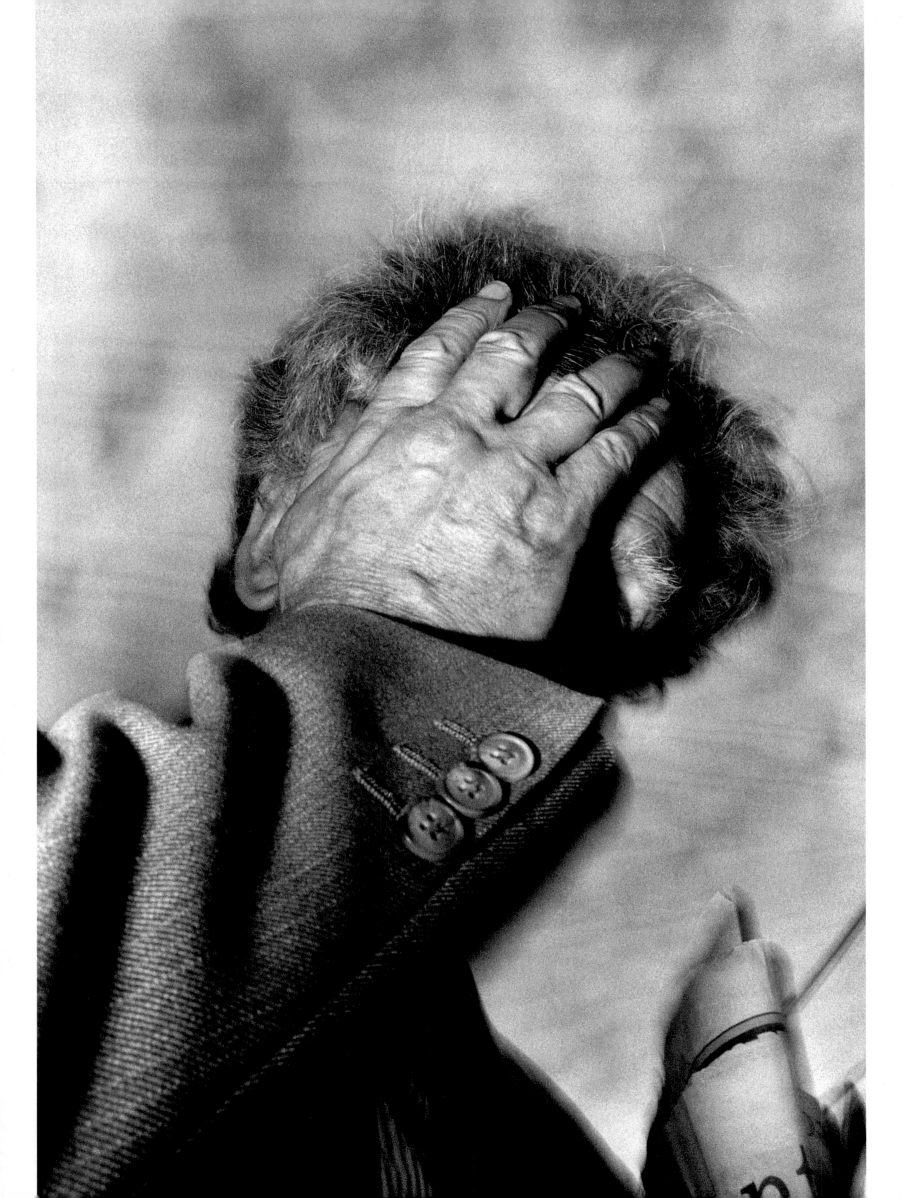

Have you anything for today, asked Murphy.

No.

I'll bet you you have.

Nothing. Nothing at all.

They sat in silence at the bar for a while till Aggie appeared. They took a whiskey each.

Do you ever think about life, asked Murphy.

No.

Never.

No, why should I.

He searched his pocket for change while Murphy watched his every move. And if there is a reason to life well it's long forgotten, he continued, so don't be bothering me.

I'm only saying.

I don't want to hear about it.

Your voice would give me a pain, snapped Murphy.

What is it but the same old story, said Tim Pat.

You owe me one pound twelve and six, said Aggie.

Good on you, Aggie, said Murphy, I love to hear the sound of old money.

Outside on the street a van door closed with a slap.

The gypsies alighted near the new forge where a young man in a crew cut was melting a rusted gate. They watched him without comment. **Nodded, nodded**. They moved through a herd of cattle without heeding the beasts. The father, a tall man with a blunt chin, was steered along the footpath by his two redhaired sons. He stopped, went on, stopped again. He lit an Afton to study a horse. He put the spent match back in its box and feeling his forehead with his free hand paused to think. He took stock of his surroundings.

Listen, he said.

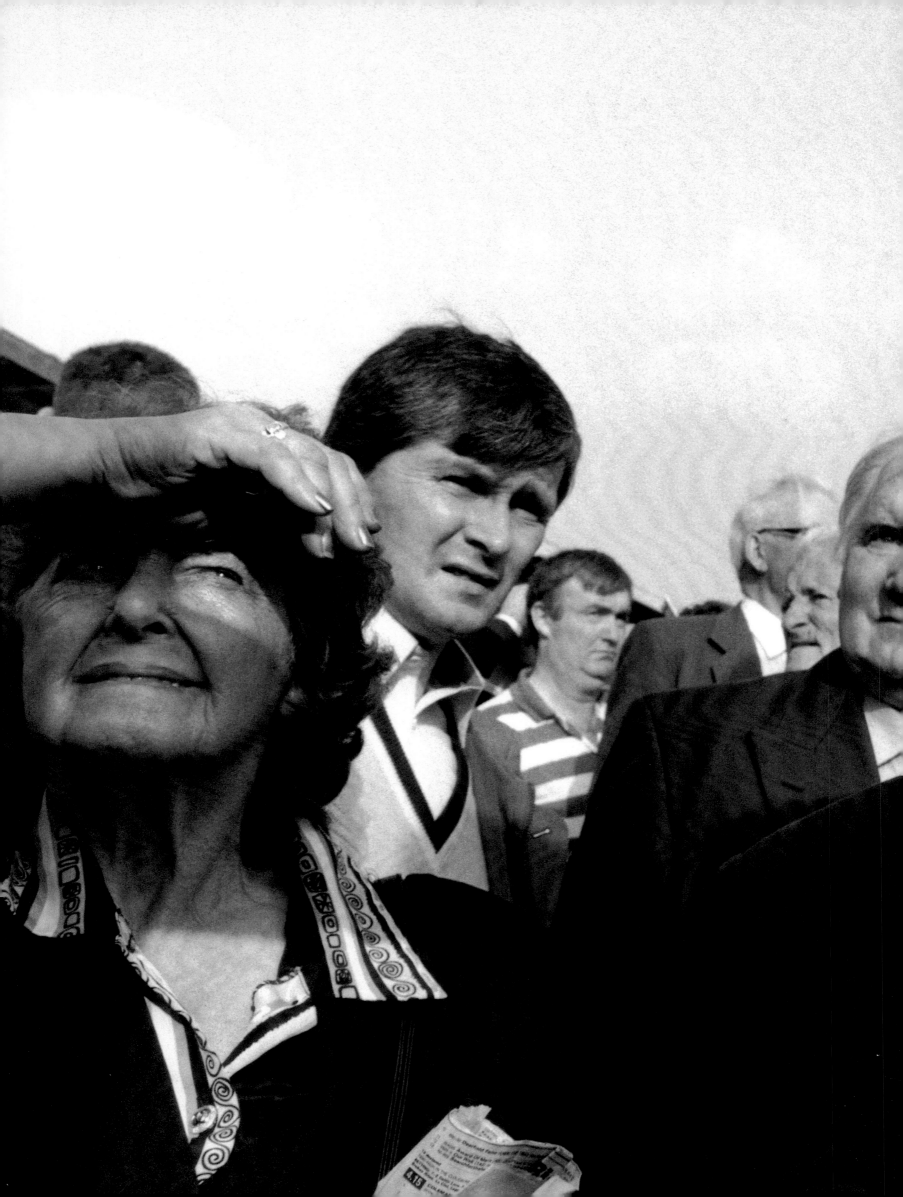

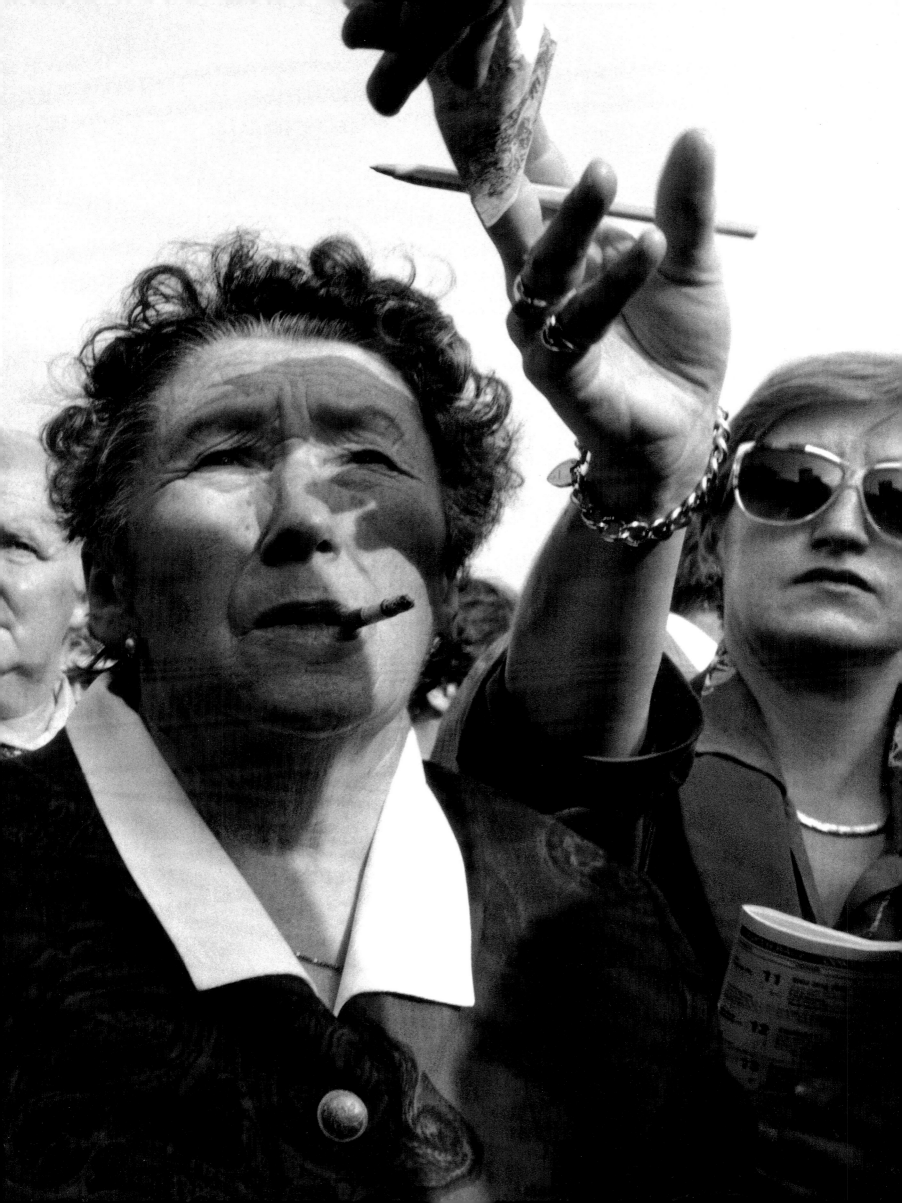

The sons gathered round. He put his arms over their two shoulders. They huddled a moment. Then they went on. The dog got up from under the monument and followed them down the street. They walked direct to a man setting up a stall of car accessories and the father bought a black waterproof torch. The seller put a battery in. The father opened his coat and lifted it out from him till it formed a tent, then he shone the torch into the dark under his armpit. Next he shone it into the face of his son. He nodded and pocketed it. They moved on to the shirts. Past the cabbages. Then to the radios. Lastly the jams.

They bought three pots of blackberry and two of gooseberry. She'll like that, said the father. One of the lads carried them very daintily. Farmers stood aside to let them past. Then they went down Lang's entry.

Murphy and Tim Pat were sitting in silence studying form. The Mangan gypsies came in the back door and moved towards the other end of the bar and collected in the dark by a low table. They sat head-to-head a moment.

> You told the guards, said Murphy rising his head from the paper.
> I did not, said Tim Pat reading on.
> Look into my eyes and say it.
> Tim-Pat looked into his eyes.
> You did, said Murphy.
> I'd be beholding to you, said Tim Pat, if you'd leave me alone.
> Those stones were for my mother's grave.
> Look, said Tim Pat, leave me be.
> Murphy slapped the seat opposite him.
> You'll deal with me yet.

The Mangan gypsies heard the disturbance without showing any concern. In the half-light they looked mournful. It was nine in the morning. A horse across the road whinnied in terror. The gypsy father clapped his coat pockets, searched around, pulled out a single twenty pound note and studied it.

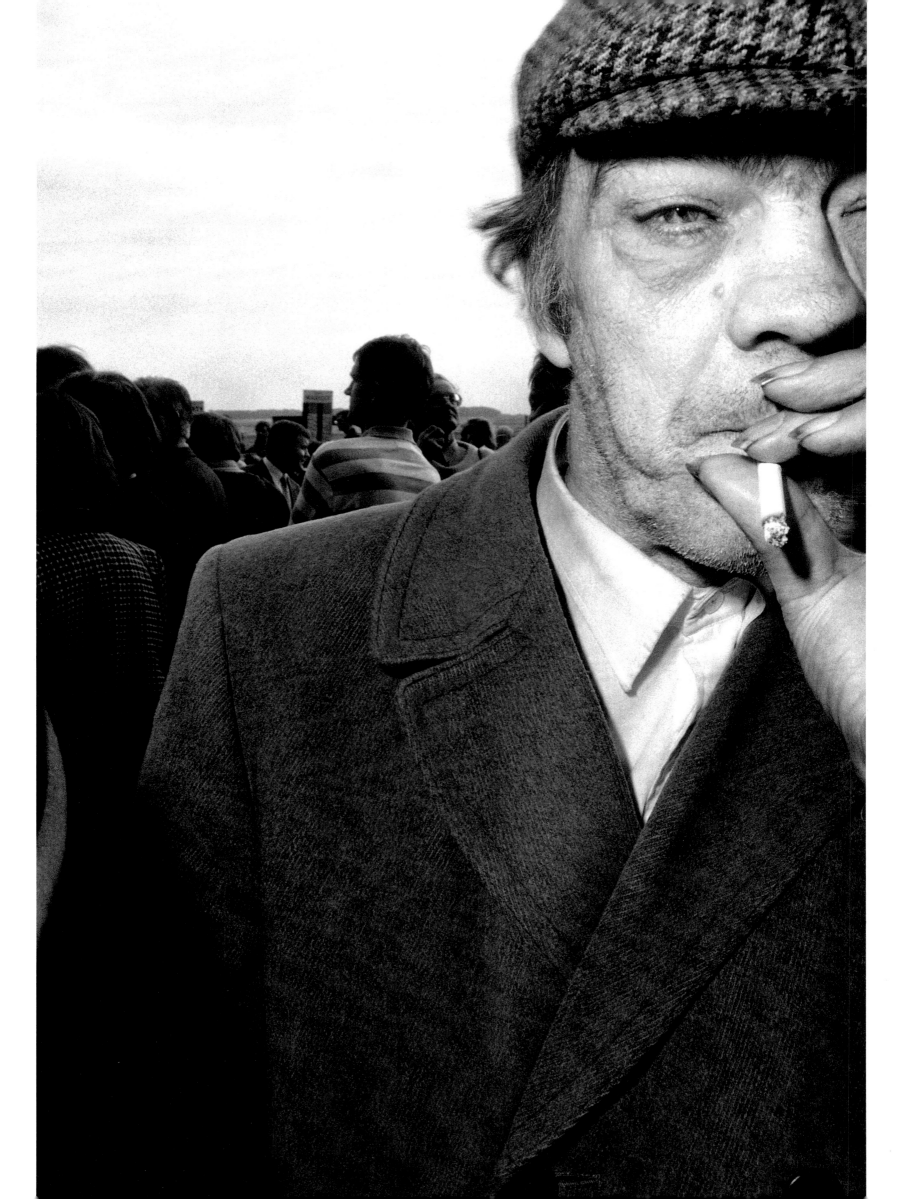

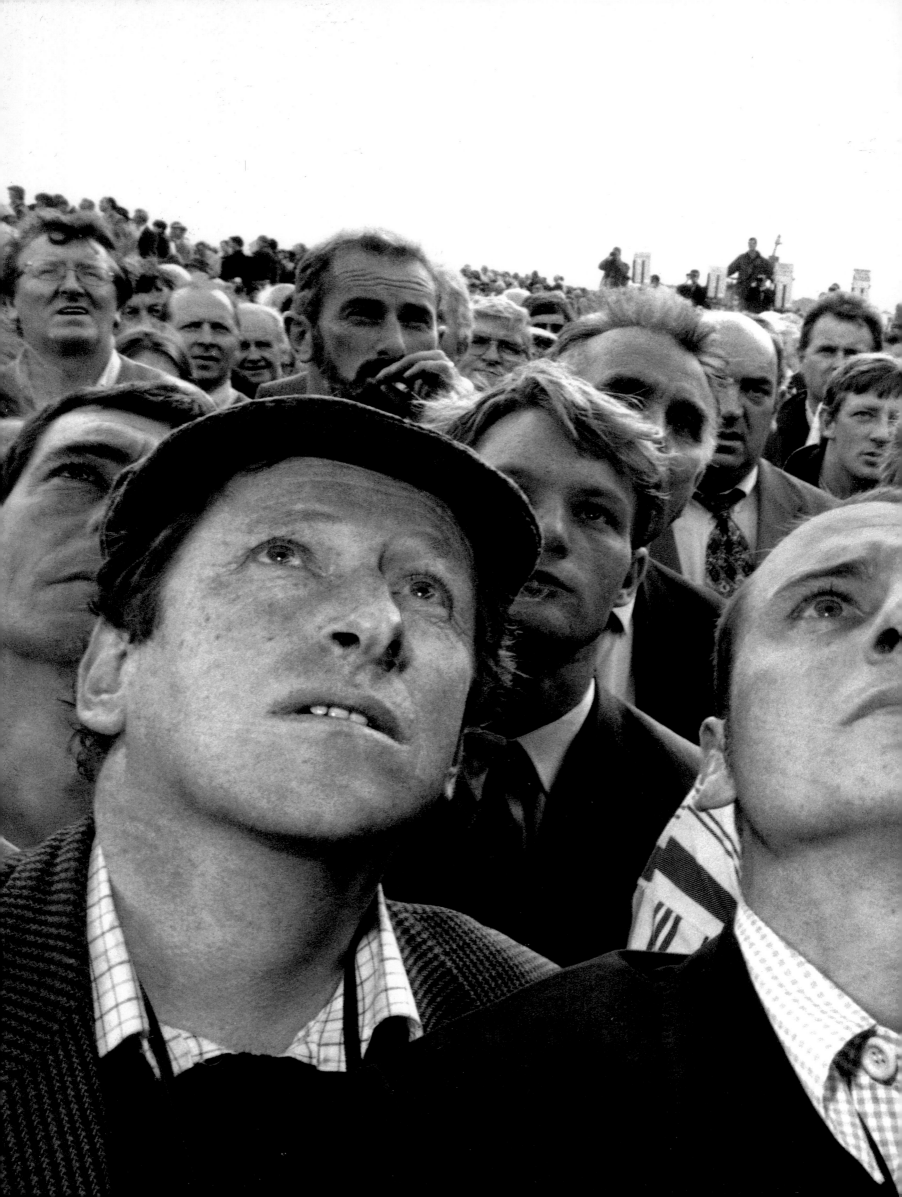

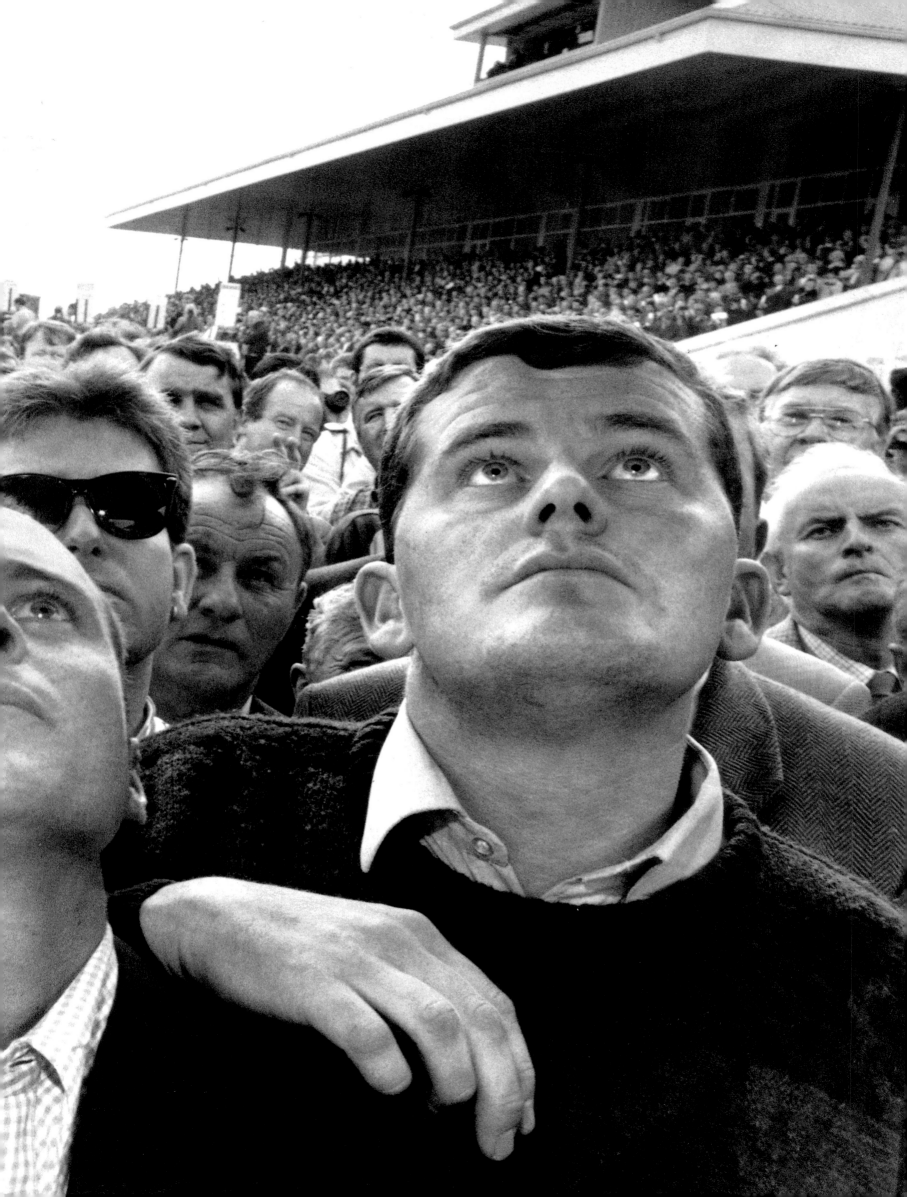

Who is this man here, he asked and he showed the note to his son.

He could be anybody, said Jaimie.

He could. But would you deal with him?

I might.

You might is right.

He studied the note, then put it away. In a low hum hooves and tractors rattled by. **A kettle whistled**.

You're a bloody liar, shouted Murphy.

It's shameful, Tim Pat said, to have to listen to this.

Waa! muttered Murphy.

Mangan took out the note again, handed it to his son and nodded. The lad approached the bar, leaned over and waited till Aggie came back from the inner room. She buttoned her blouse and beat her skirt.

Yes son?

A whiskey M'am, he said, and two pints a' Heineken.

Whiskey, she repeated uncertainly.

And two pints of Heineken, he said louder.

You know, she said, that if I serve you it's illegal. Opening time is half-past ten.

The lad nodded and looked at the drinks in front of the other two men.

Those men are employed by me, she said. They are my handymen.

He seemed to fret and looked back at his father and then at her.

Alright then, she said, just this once.

Thank you Mrs.

She lifted a glass to the light.

I didn't know where I was. Did you ever get that?

I did, said Tim Pat.

All that abuse over the radio, she continued. And it never stops.

There was a time you'd hear music.

There was.

And I never slept a wink last night.

Tim Pat took a draw of his pint.

Good luck, he said to the gypsy lad.

That it may sicken you, came Murphy's voice behind him.

Dear God.

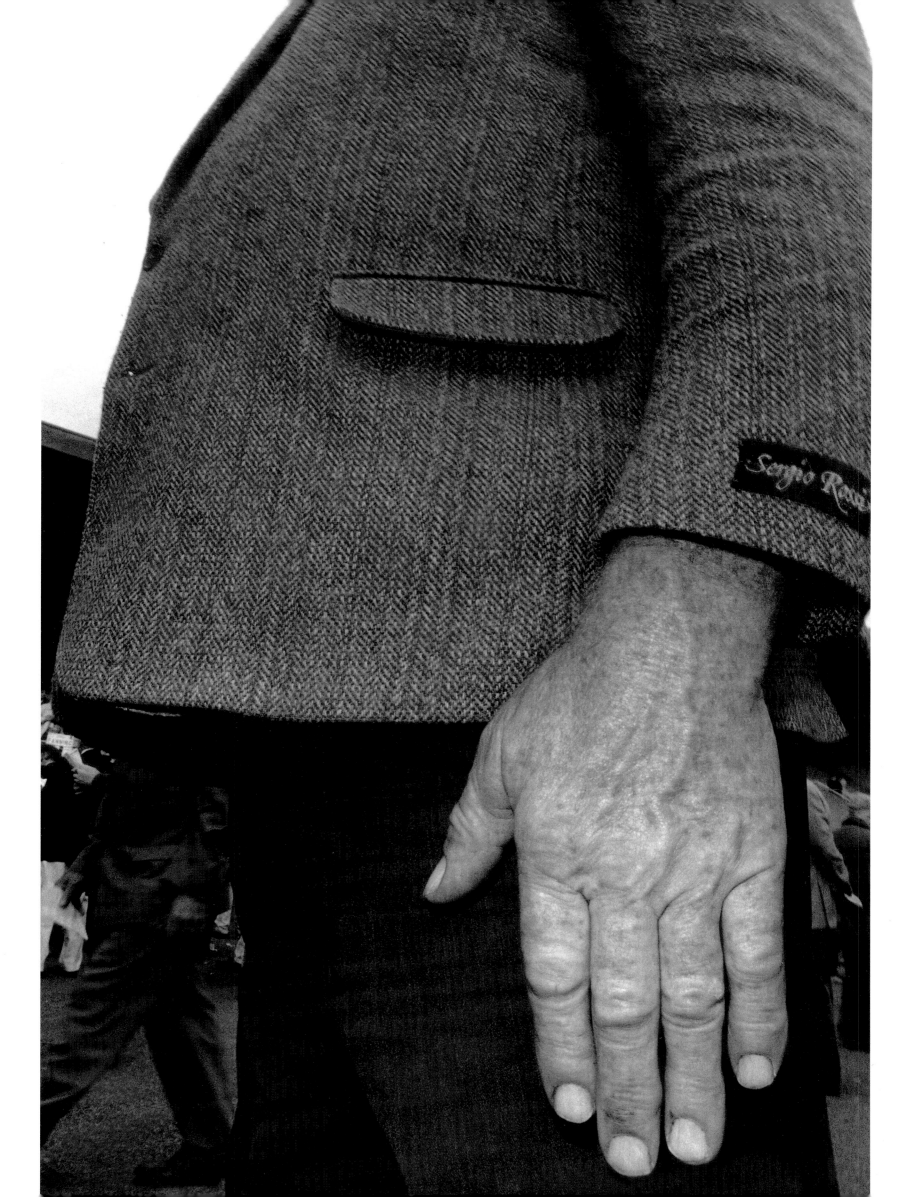

I don't think he likes you, said the lad.

So it appears.

It was you, shouted Murphy. It was you!

Not me, said Tim Pat, not me, my good man.

Don't my good man me!

Keep it down, said Aggie.

Murphy got up and stood by the gypsy with his hands grasping the bar-rail and his arms out-stretched.

Do you see that man there,

he asked the lad and he hauled himself onto his toes.

I see him, young Mangan said without looking.

That man there is well in with the guards, he sneered

then dropped down to normal size.

You'll get that, said Jaimie.

You'd wanta watch him.

No problem, Mister, he said.

I was just warning you.

I hear you.

We're dealing with evil here.

God-in-heaven, said Tim Pat.

It's not our business, boss, said the lad.

I know that, Murphy said with a leer.

It's not our business, the gypsy stated again in a flat calm voice.

When he heard the menace, Murphy changed tack.

Are you for the races? asked Murphy genially.

No.

No?

I'll tell you what my business is. This is since you want to know.

His thumb wandered over the bar. We have to be in Tuam be twelve.

The uncle died.

I'm sorry for your troubles, said Tim Pat.

Ah now, said Murphy.

So it's not our business.

No.

Do you see now what I'm saying, asked Jaimie.

I do, said Murphy backing off.

It's not our business. Not ours. He turned to Tim Pat.

My father lost a brother this morning. We're for Tuam.

Take care, said Tim Pat.

Meself and the brother, he said, will drive. That's what we'll do.

I'm only saying, said Murphy and he went back to his chair.

And I'm listening, said Aggie. She sliced the top froth

of a high pint of lager with a knife. **Two pints and a whiskey.**

Does your father want water.

No M'am.

Neat. He likes it neat.

That's right, M'am.

That's right, she said. Your people like it neat.

She smiled abruptly. Young Mangan took his change and drink.

See you boss, he said to Tim Pat, and ducked away.

What were they saying to you, asked the father.

Nothing, said young Mangan.

The less said the better.

His son put the change on the table and the father

separated it into two lots, then lit a fag.

There's a pony running today has my fancy. I want that on him.

Right.

Good man, that's settled then. He shook the fag in front of

his face and brought his head forward. They followed him with their heads.

Listen, he said.

I can't sleep for the life of me, said Aggie.

I get nights like that, said Tim Pat.

You must have something on your conscience, interrupted Murphy.

I have indeed.

What is it?

You.

I don't like that, said Murphy,

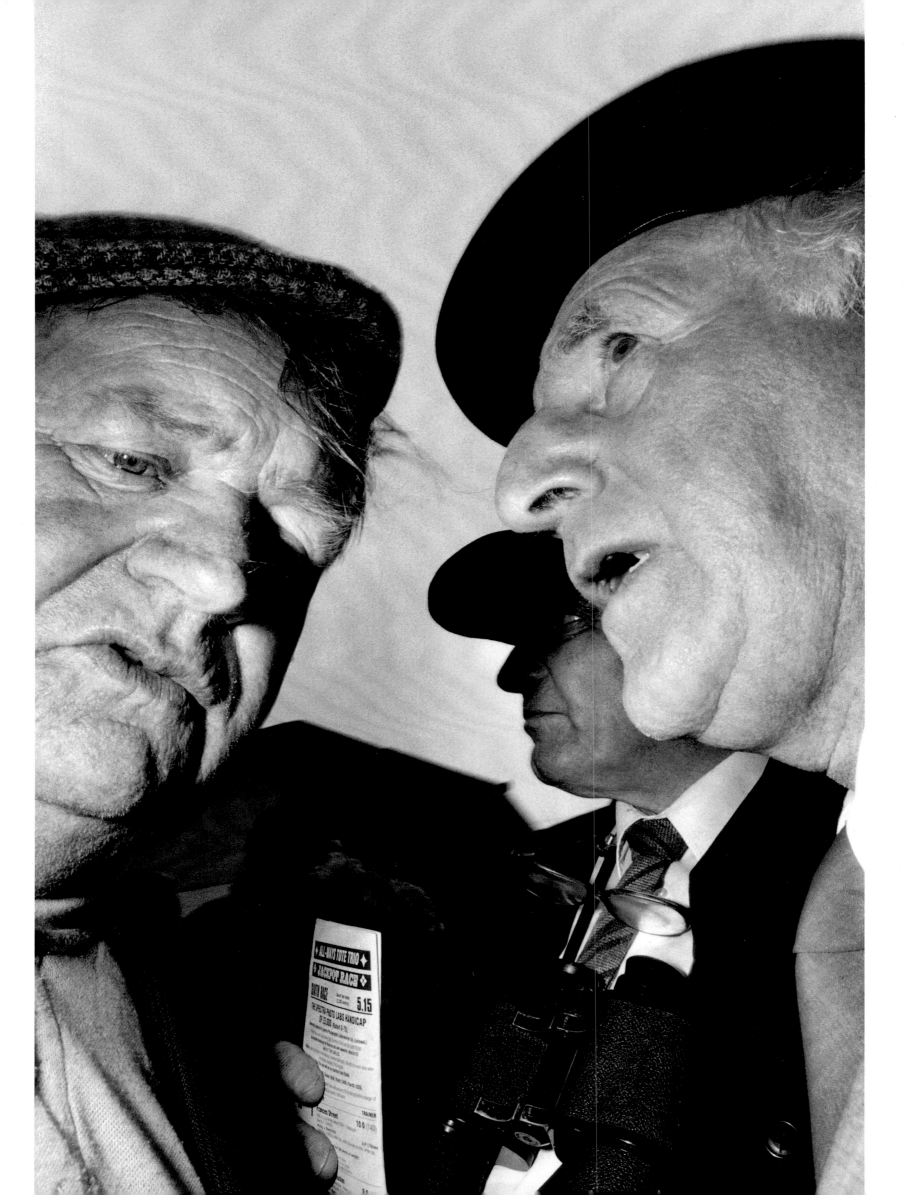

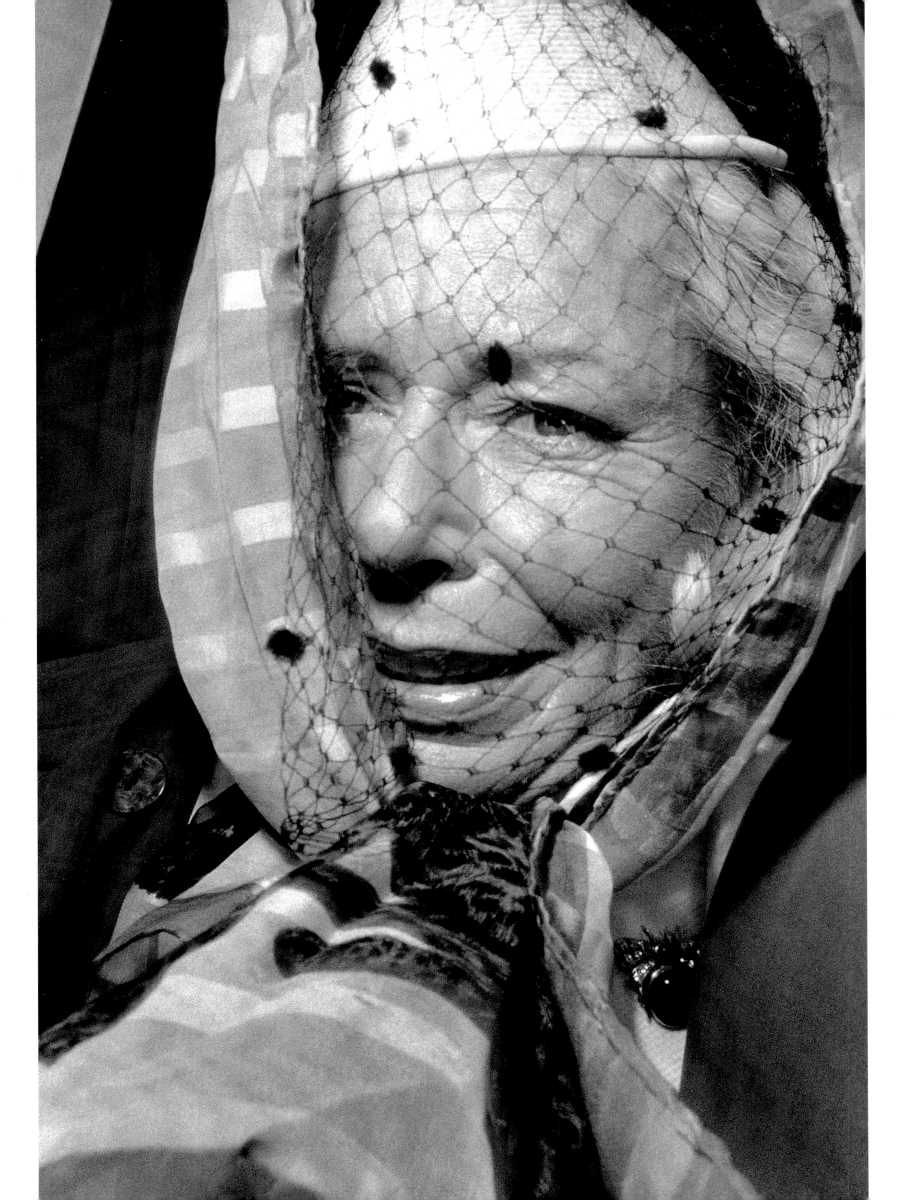

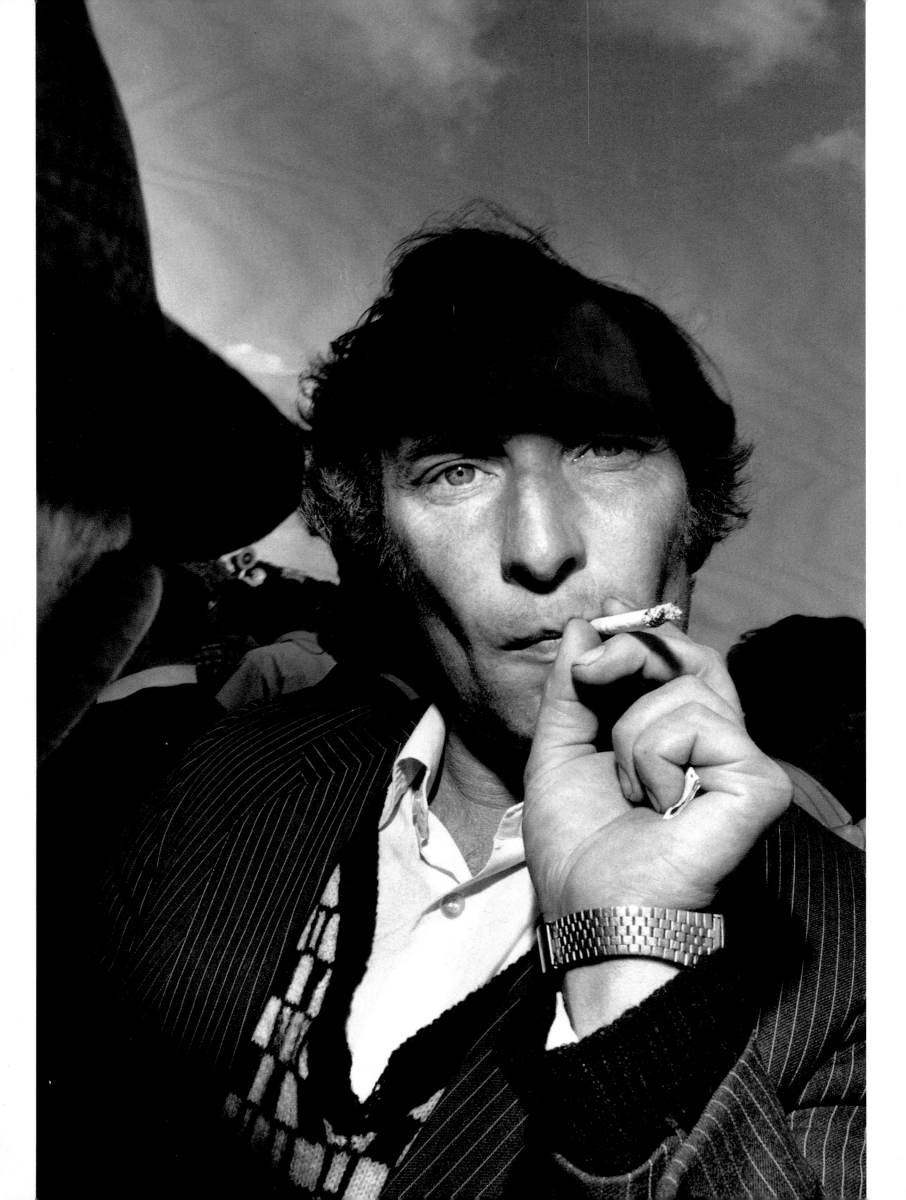

I don't like that at all. You're at it again.

He got up and stood stock still with his face in Tim Pat Banks's face.

I heard what you said about me.

I just said you keep me awake.

Well I never lost a night's sleep over you, said Murphy. And I don't intend to.

Well don't.

I won't.

The two neighbours stood face-to-face, one man in a cap,

the other capless, Murphy's hair askew and Bank's hat tilted back,

both touched **like rare things**.

The pair of you, said Maggie, make a pretty picture.

Go on, Banks.

Go where.

Go on, try it.

My sporting days are long past, Peadar.

Sport my arse.

I was in the 100 yards once, said Banks, and I was disqualified.

Why, asked Aggie.

Because my nose was running, and he broke into a fit of laughter.

Jesus Christ help me, complained Murphy. He's trying to steal inside my head.

I am not, for fuck sake.

You damn well are.

Jesus Christ, Peadar.

I know you!

Mr Murphy, said Aggie.

Yes Aggie.

Will you have sense, my good man.

La-de-da, said Murphy, **la-de-da**.

Ya clam ya, she said.

Get out of my light, said Murphy, and he headed off to the gypsies table.

Maisie Sheridan looked into the cold room in the Irish House Hotel and took out the prawns she had defrosted the night before. She cut parsley with Gertie. Then the French chef peppered the legs of lamb with mint and garlic. He parboiled the potatoes and scored each to make a bed for cheese and spring onions. He placed them in a tray.

Will there be lobster? he asked.

That's up to Bernie, she said.

Did you see Mattie?

No.

Where is he, she said, where is he?
To go and disappear on race day.
He'll be here.
Freddie, she screamed.
Her son came down the stairs.
See can you find your father.
Alright, he said.

Do you mind if I join you? asked Murphy.
Mangan gave him a keen eye.
Am I interrupting? Murphy asked.
You're not interrupting, said Hughie, the other son.
Just tell me now and I'll go away.
You're alright, said Hughie.
I'm sorry for your troubles, said Murphy to the father.
Mangan said nothing.
I still have my dignity, said Murphy to none in particular, which is not my own fault.
Do you have a tip for today?
I do not.
Are you not working, boss,
asked the father.
I spent the morning in the graveyard,
talking to them.
Ah.
And I laid a bed of stones on my mother's grave.
God rest the dead, said Mangan.
I know them best of all, said Murphy.
The dead?
That's right.
They're gone, said Mangan.
Murphy strode to the window,
pulled back the curtain and looked out on the town.
Did you ever notice that drunkenness,
he said, makes us all look like each other?
I did and I didn't.
Do you mind if I sit?
Sit if you will.
If you don't want me to I won't.
If you sit there you have your reasons.
I mean no harm.
There was a silence.

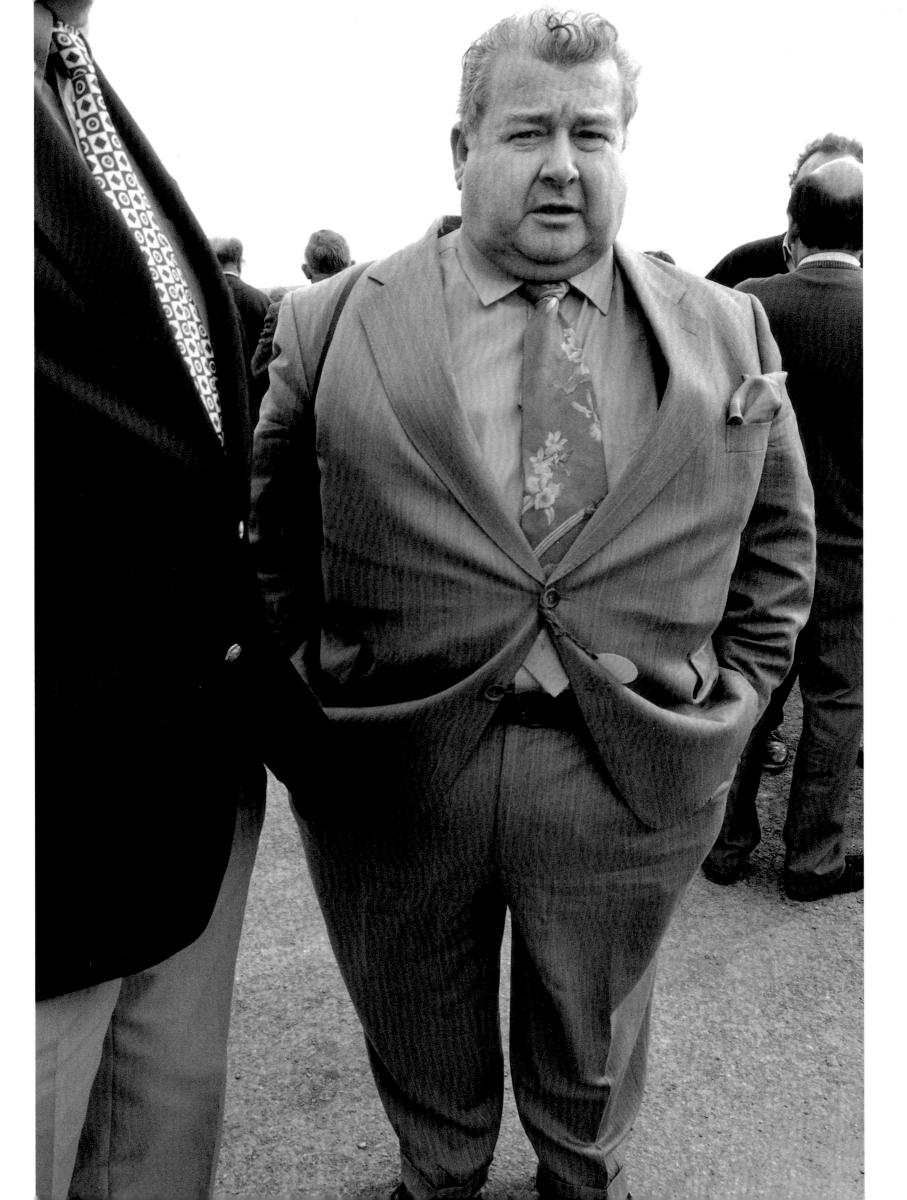

You were out early.

I was, said Murphy. I was.

You'd be sick.

I'm scourged, he said.

He sat down and put his head in his hands.

I'm sick, I think.

He looked at one of the younger Mangans—Hughie.

The tall 30 year son was wearing a boy's face.

Murphy lifted his head and grinned.

He stared into a safe place but the grin continued on.

He put his hand to his head.

My neighbour

has me cap, he said.

The father

has a cold

in his chest,

said Jaimie.

I caught it in Clones, the father agreed.

There's nothing worse than a cold in the chest. Then he changed his legs.

On the dot of opening time Tim Pat pulled back the locks on the front door and undone the gate outside. He closed the door behind him and headed down the town to the bakers to get pastries for Aggie.

He saluted those he knew, stopped off for The Independent newspaper and changed his mind and bought The Sun. Then he changed his mind again and bought a rhubarb tart instead of pastries because it looked so fresh and wholesome. Passing the church at the top of Bridge Street he blessed himself. Kitty Shore wished him a good day.

At Langs all was as he left it. Aggie cut the tart in slices and Tim Pat brought four to the gypsies table where the father thanked him profusely, then he took one himself. Aggie sat down under the window to watch the street. She had a cup of tea in one hand and a slice of tart balanced on a beermat in the other. She laid down the cup and beat crumbs into her lap.

Lovely, Tim Pat, she said.

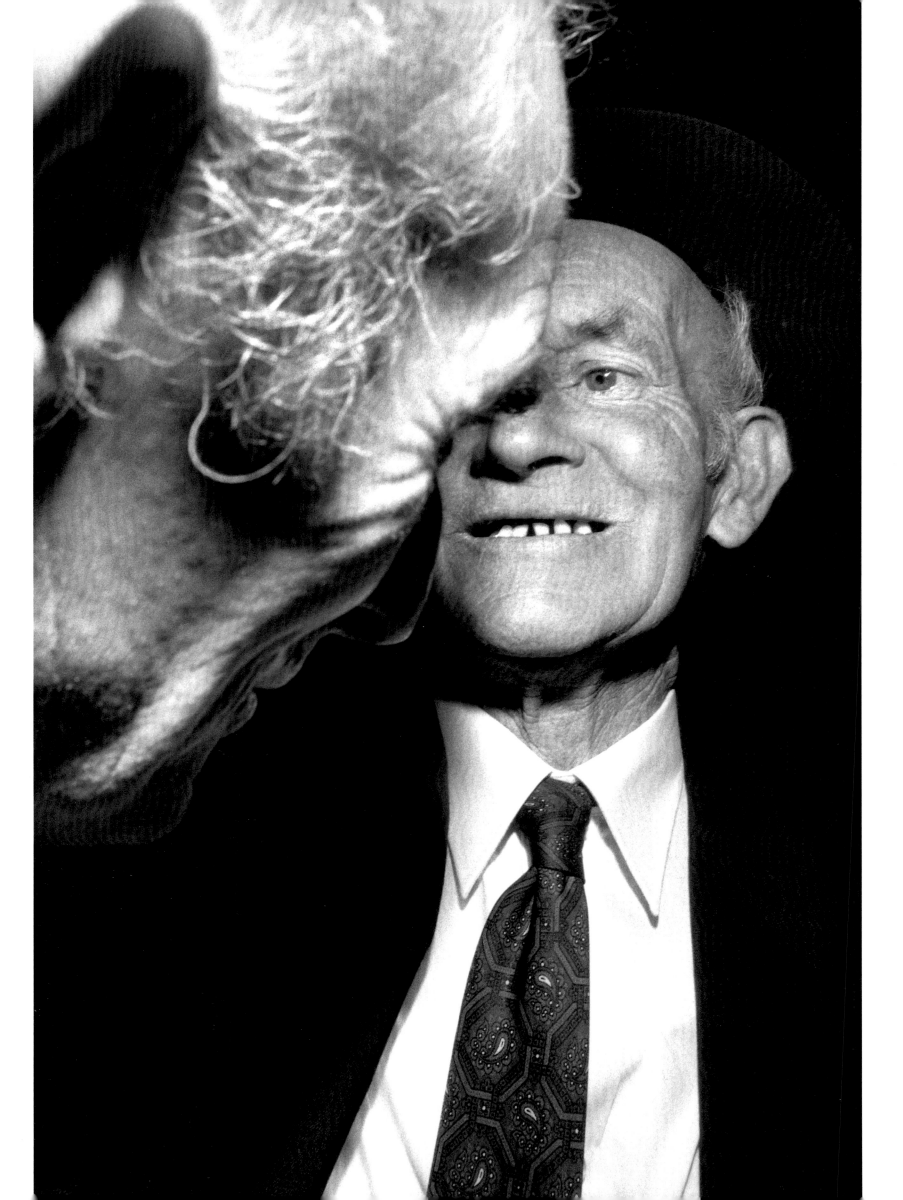

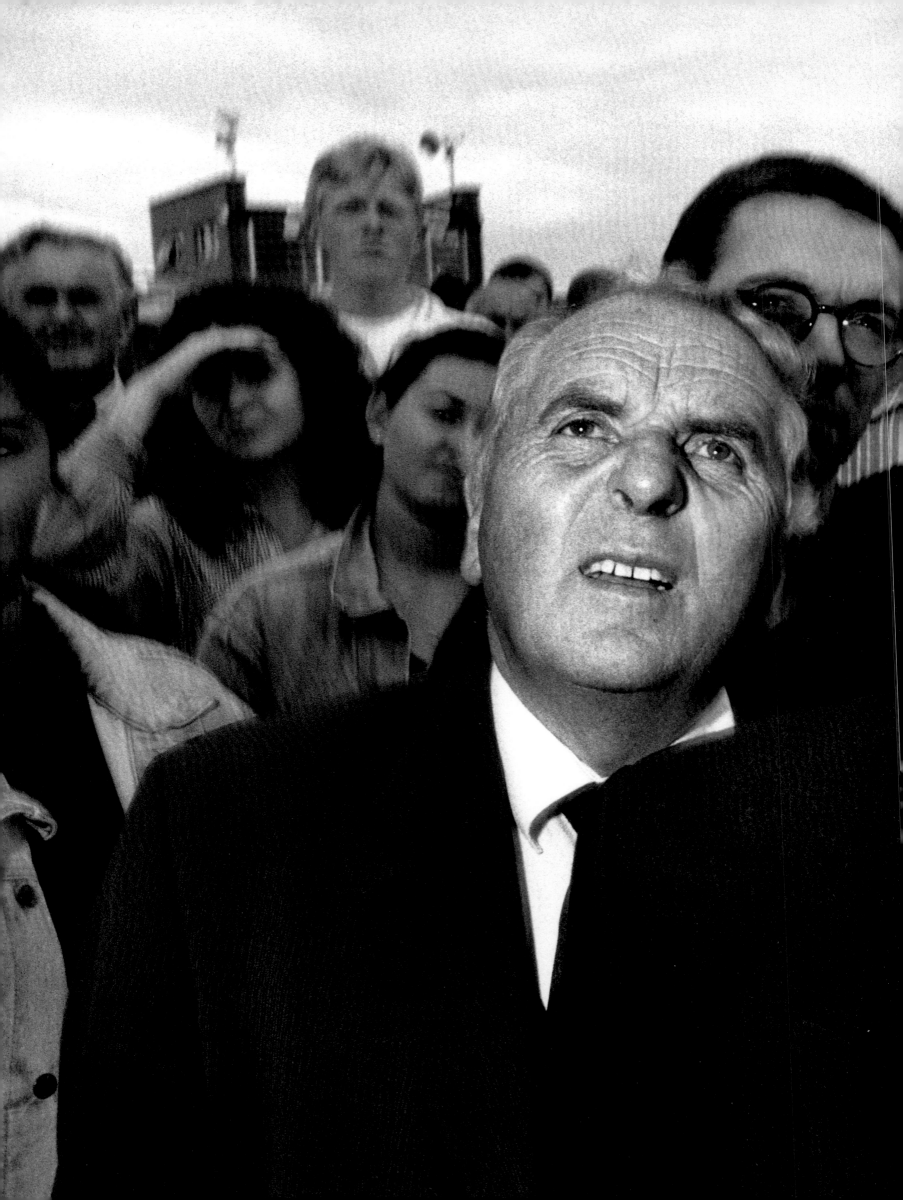

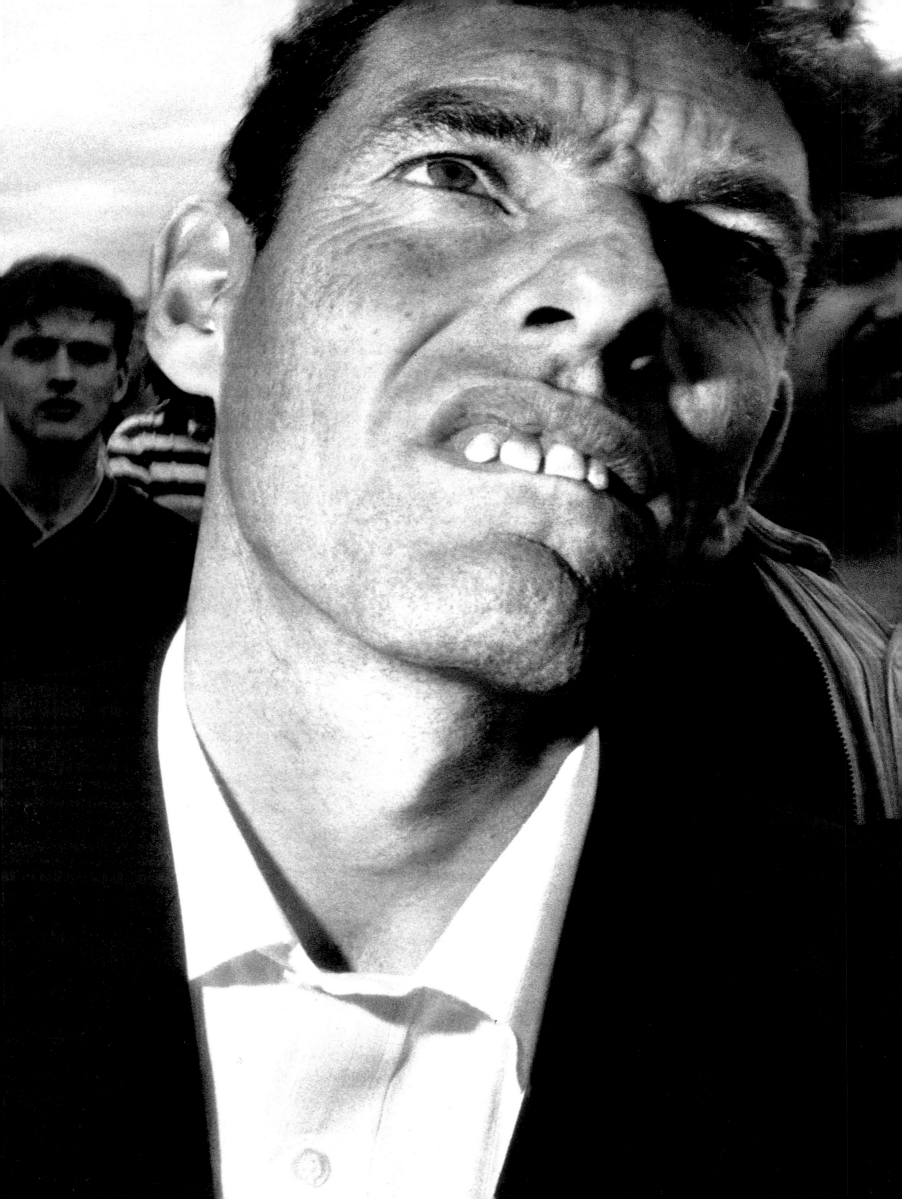

Would you care to buy an eagle? asked Mangan.

No thanks, said Murphy.

They are the best of eagles.

I don't doubt it.

We could make a deal.

For an eagle?

An eagle surely.

Mangan curled his hand. Murphy shook his head. Mangan spat.

Name your price, he said.

I can't.

She has her claws.

I don't doubt it.

Suit yourself, boss, said Mangan dismissively.

But I have nowhere to put it.

Wouldn't the pier of the gate do, boss.

The pier of the gate? asked Murphy astonished.

Aye. Its the best of plaster. Very weather proof.

And there's some have claws and some that don't, but mine do.

No thank you, said Murphy.

He knitted his brows and looked to the left where the virgin, slightly tilted, sat like a goldfish in her glass vase in the plush part of the lounge. She is cursing us, he thought, and telling us things we can't hear. **Testing**, said the voice again.

Testing, testing, called a distorted voice from another world. Testing, one two three. Another silence that was filled with urgent waiting. Testing! Then it began. For a sudden it sounded like the call to prayer at first light. **The loudspeaker shrieked.** The echo raced across the market square, down past the second-hand clothes man with his Fiat van stacked with yellow rain gear, donkey jackets with leather shoulder pads, combat trousers and wellingtons; up the aisle of the open church where a woman in a beret was watching a single candle flutter in the dark; it hurried the steps of two farmers that had to park on the outskirts of the overcrowded town; it was only an echo in the Fawlty Towers bar; it was splitting the ears of a man buying young fir trees by the monument; it frightened the calves who heard its manic prayer somewhere back in their genes; round the ring the men's faces never twitched as the pitch sharpened into a whine of

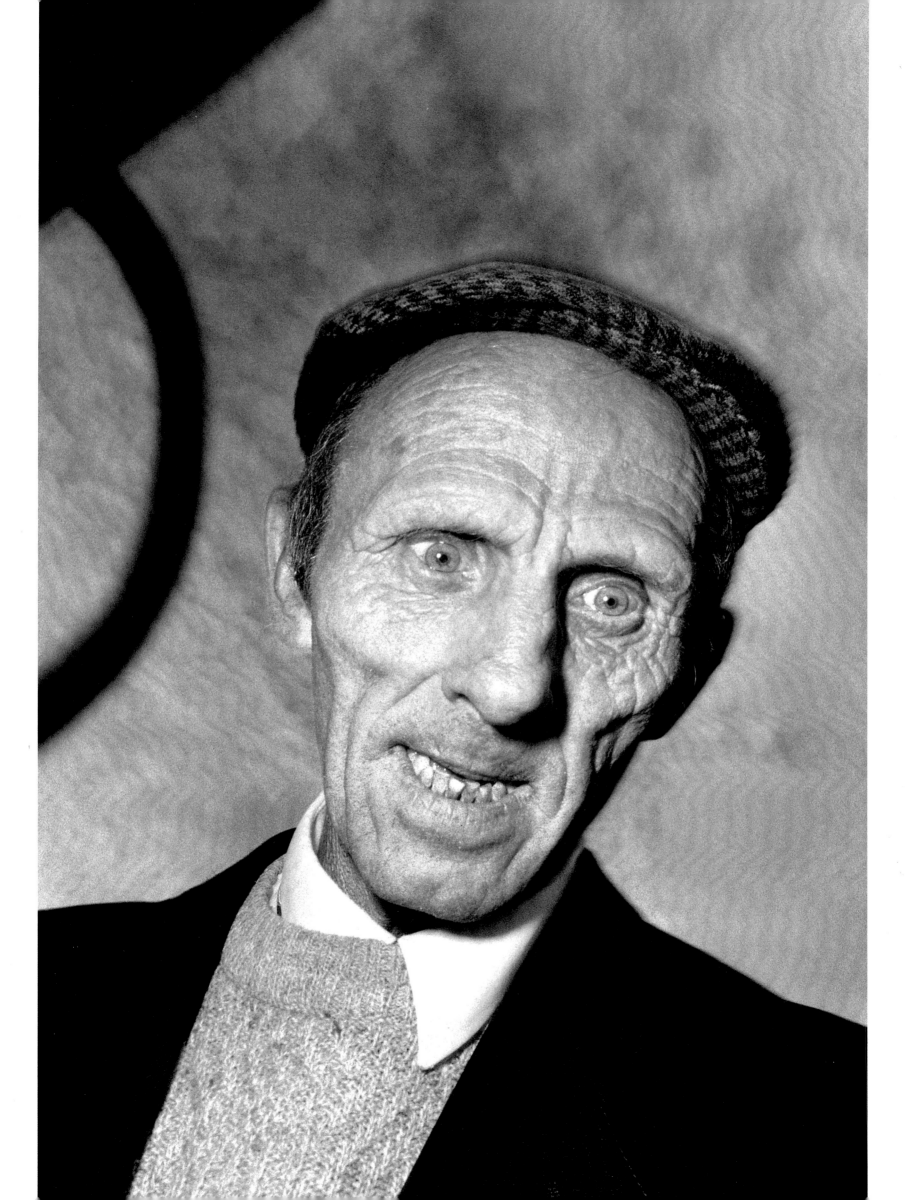

fine gibberish; the speaker spoke to someone down out of sight below him in his cubicle; he shook his head, he was not having it, he was having none of it; a heel came down on a cigar, Excuse me, asked a neighbour of a neighbour, is this your lot?; below the speaker **a lad dusted the sold lambs with splashes of yellow and blue from a can of coloured aerosol**; on went his master up and down the scales, halting only now and then at the nod of a head or a finger raised; it stopped, the hammer went down, the harangue started again: a man raised his cap on the highest step of the enclosure, steam rose from the cattle in one of the steel pens; horse boxes trundled down to the race course; Some ewes with teeth, and some with none, called the auctioneer, what am I bid?

It's started, said Mangan.
Murphy listened with genuine sorrow.
You're moving too fast for me, said Murphy.
Is there something wrong boss?
The world is not what I thought, so I suppose I changed the expression on my face.
He's crying, said Jaimie.
I'm not. I have a **weeping eye**.
I've heard of that.
I often woke to find the pillow soaked.
You'll get that from the batteries, said Hughie, if they spill.
You will, said the father.
The other day, Jaimie explained, we shifted a thousand and forty.
There's an art in numbers, said Murphy.
Is there, he asked.
There is.
Daddy.
Yes?
What number are we at now?
We have not reached a figure as yet, said Mangan.
Well can we take the number eight? asked Murphy.
Eight will do, said Mangan, I can manage eight.
Well there were eight persons in the Ark.
Do you tell me.
I do.

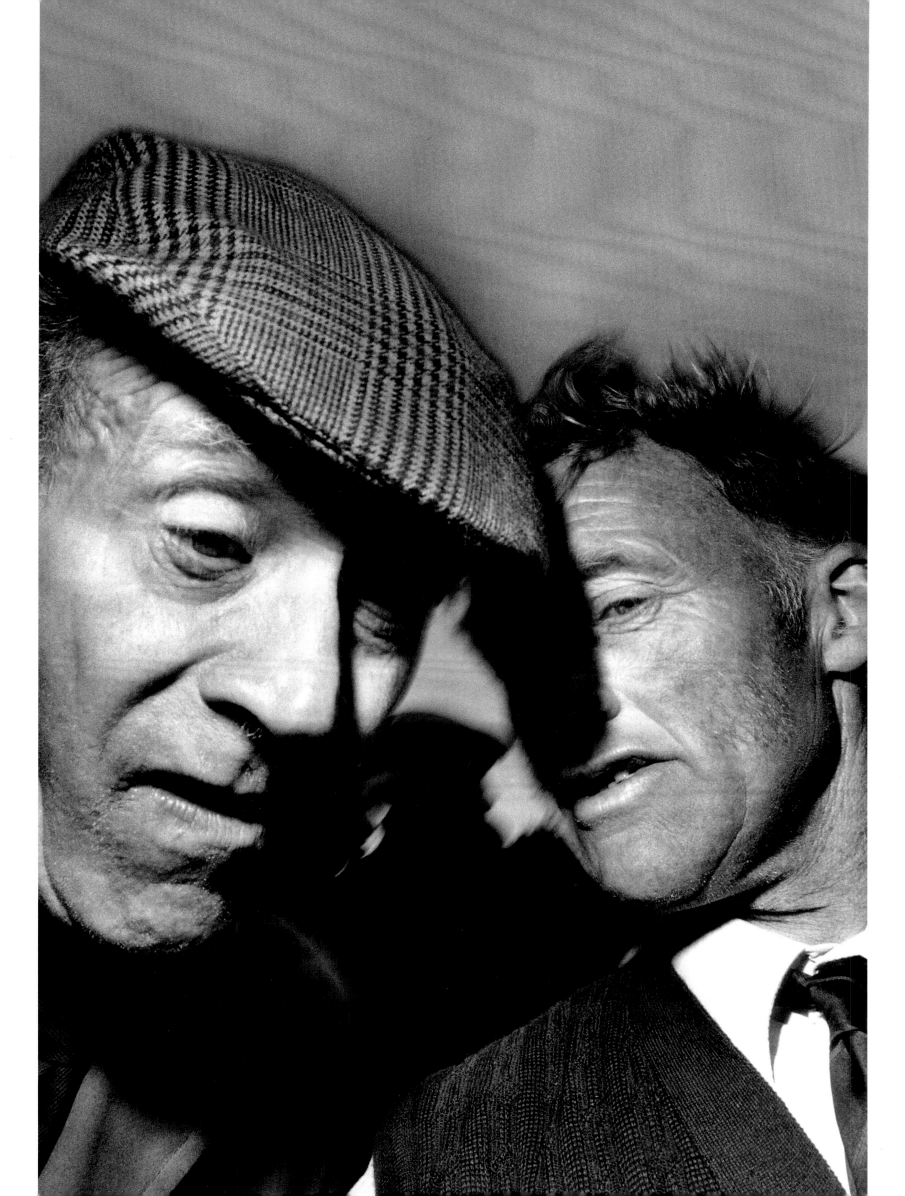

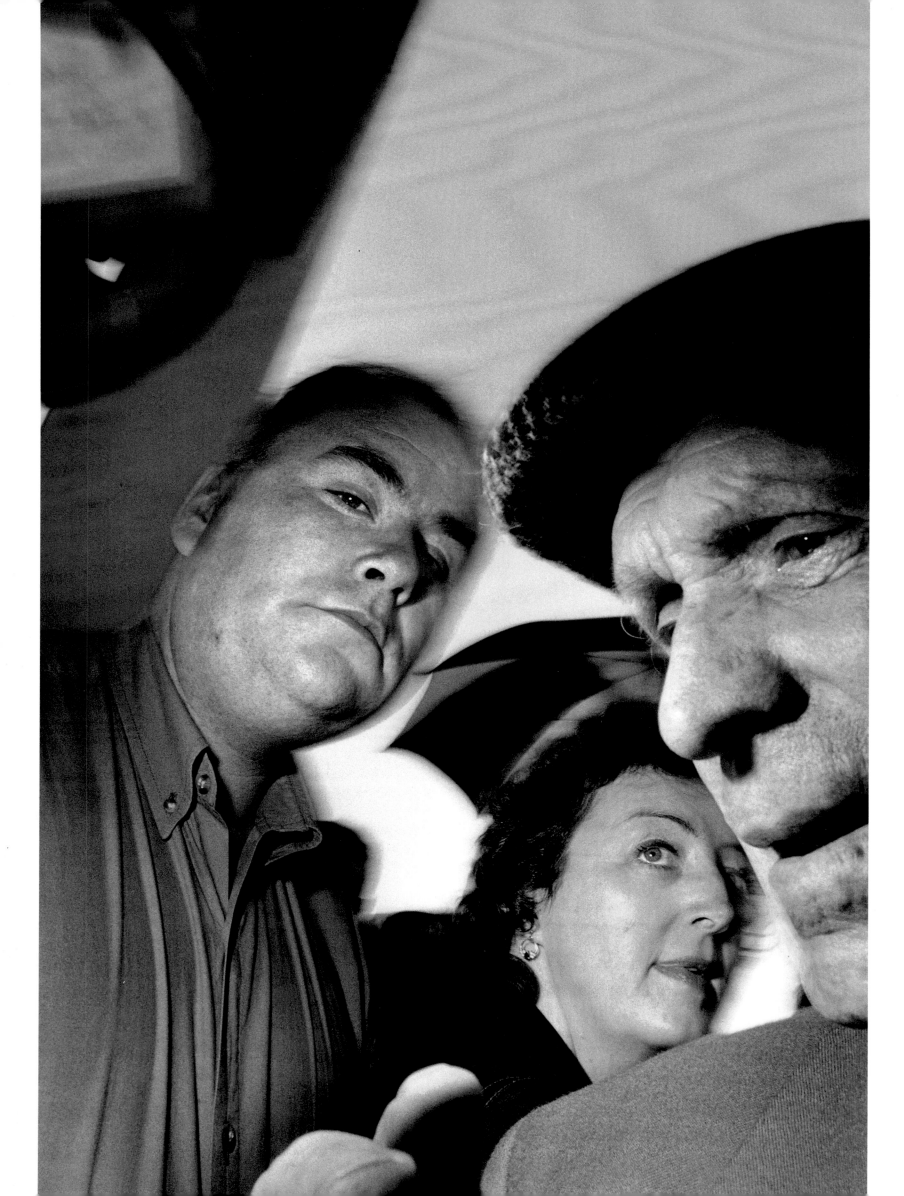

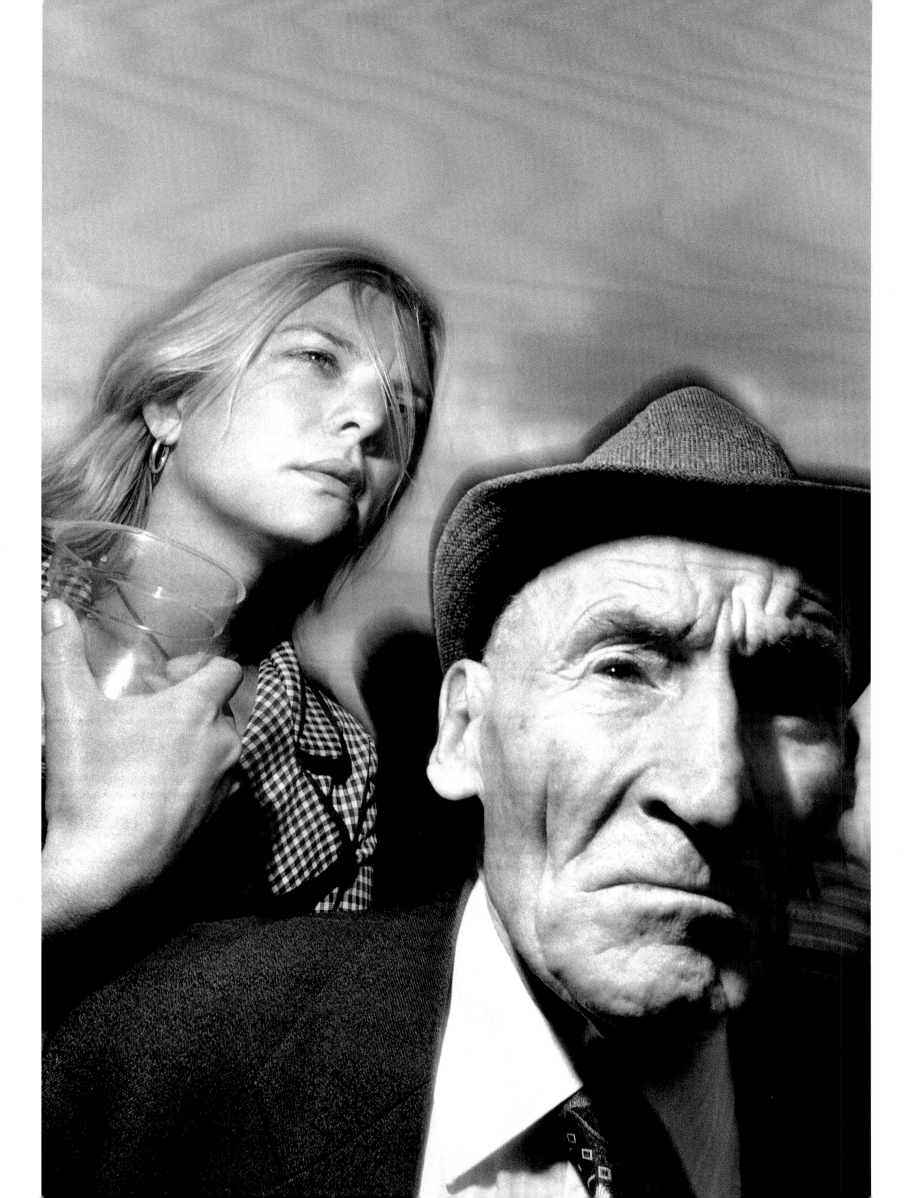

Eight persons in the ark, the father said and shook his head and whistled.

That's a fact.

Including the boss?

Including Noah.

Now. He whistled again to himself. He must have done away

with a good few to get it down to eight.

And God so loved the world he gave his only son, said Murphy.

That he did, said Mangan.

He did.

And Mary had two right feet, added Mangan.

And the Christ child had two left feet, agreed Jaimie.

Same as myself, said Hughie and he laughed.

Don't blaspheme, ordered his father, you'll bring us bad luck.

They sat in silence with Murphy going from face to face and meeting no-one.

Bernie Buckley left his house and travelled along the beach to the town. The billows were smoking. He pushed out the boat and checked his pots. He got four lobsters. He sat on the pier a while.

A helicopter flew over his head.

He stood to watch it. In the market yard the dealers stood to watch it. It swooped low over the town and echoed like thunder through the open door of the Town Hall where the morning court was in session. A guard on duty at the door shaded his eyes with his police cap to see her go. Aggie heard it. Murphy missed it. **A man with a banjo** stepped down off the ten o'clock bus from Dublin and stood at the cross to hitch to the races. Then another helicopter with its nose set towards the racecourse shot by. The musician waved at it and gave her the thumb. Bernie Buckley arrived on Main street and went into the Irish House for tea and a ham sandwich. He stirred **a spoonful of mustard** between the slices of bread.

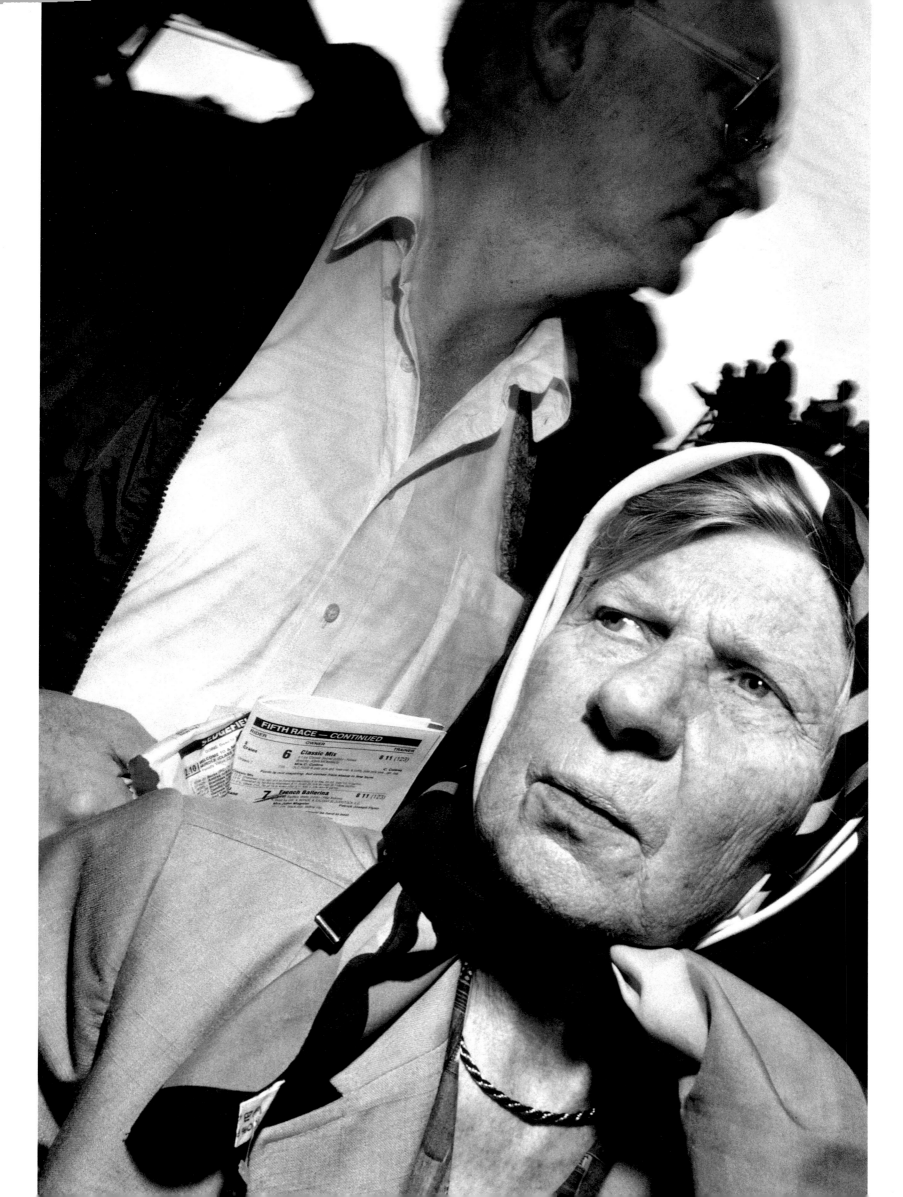

FIFTH RACE — CONTINUED

RIDER OWNER TRAINER

6 Classic Mix 6 11 (120)

7 French Ballerina 6 11 (120)

Charlie Swan flew over, he said to his neighbour.

Was that him?

It was, I'd warrant you.

He wiped his mouth with a tissue.

He'd be in the two o'clock hurdle, you see, he said.

He went into Maisie Sheridan with the lobsters. In the backroom Kitty her sister was preparing **smoked salmon with prawns and potato salad with chives**. The plates were wrapped in cellophane and taken out to the van because the Irish House had the restaurant contract for the day. When the van was full Mattie Sheridan appeared at the back door with his son.

So there you are, Maisie said.

I was only up the street.

I need you here.

He sat into the van.

I'll be back at one, he said.

On the dot?•••

••On the dot.

Don't get caught up now.

No. No I tell you.

Maisie exchanged money for the lobsters.

Tell me this Bernie, she says.

Aye.

If you see my man out there send him home.

I will.

Just tell him to come home.

I will.

Bernie stopped off at Langs.

Tim Pat, he says.

Bernie.

Peadar.

Bernie.

Good-day men, he said to the gypsies.

I had a swan break her leg on the lough, he said to Aggie. And you want to hear her mate. He's stricken. And there she is roosting in a pool of blood. I could do nothing.

You could not.

It shows you how little you can do, said Bernie.

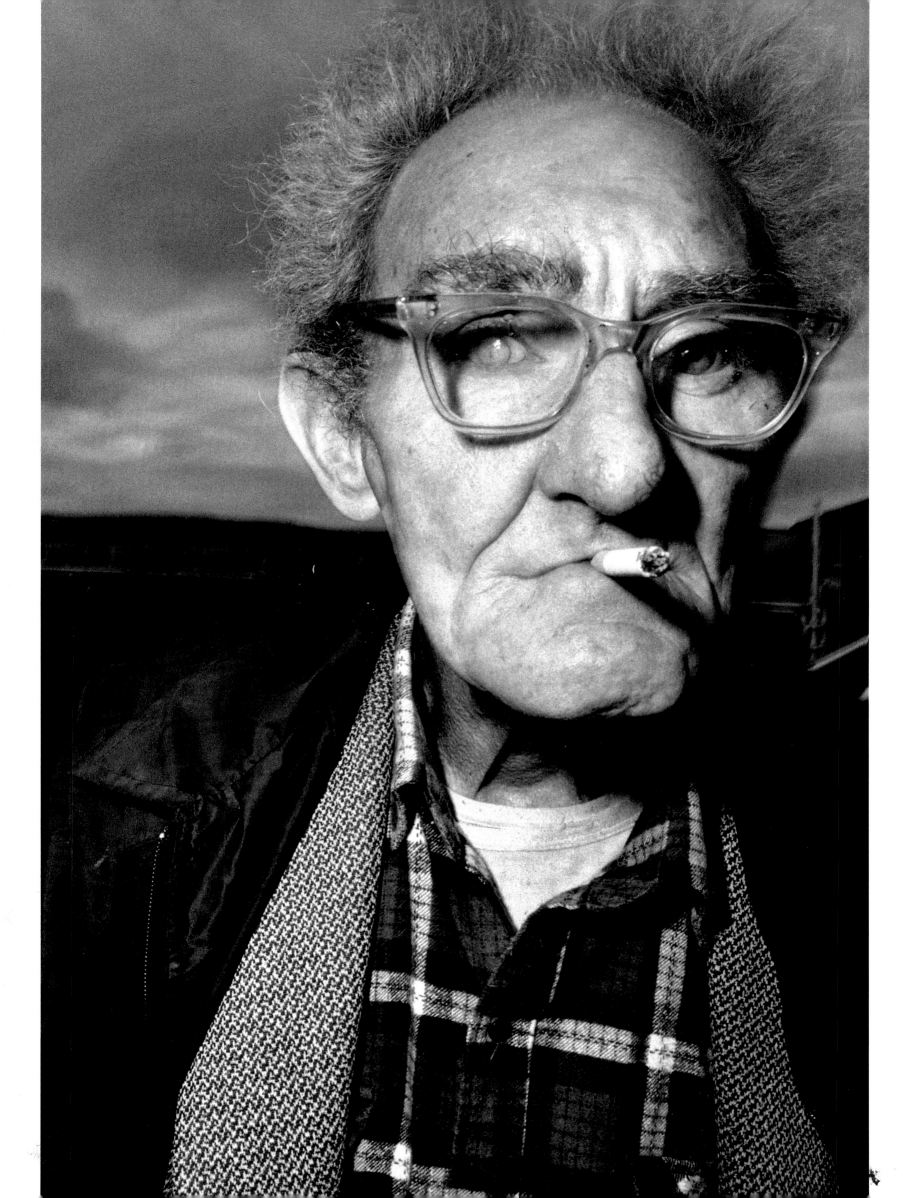

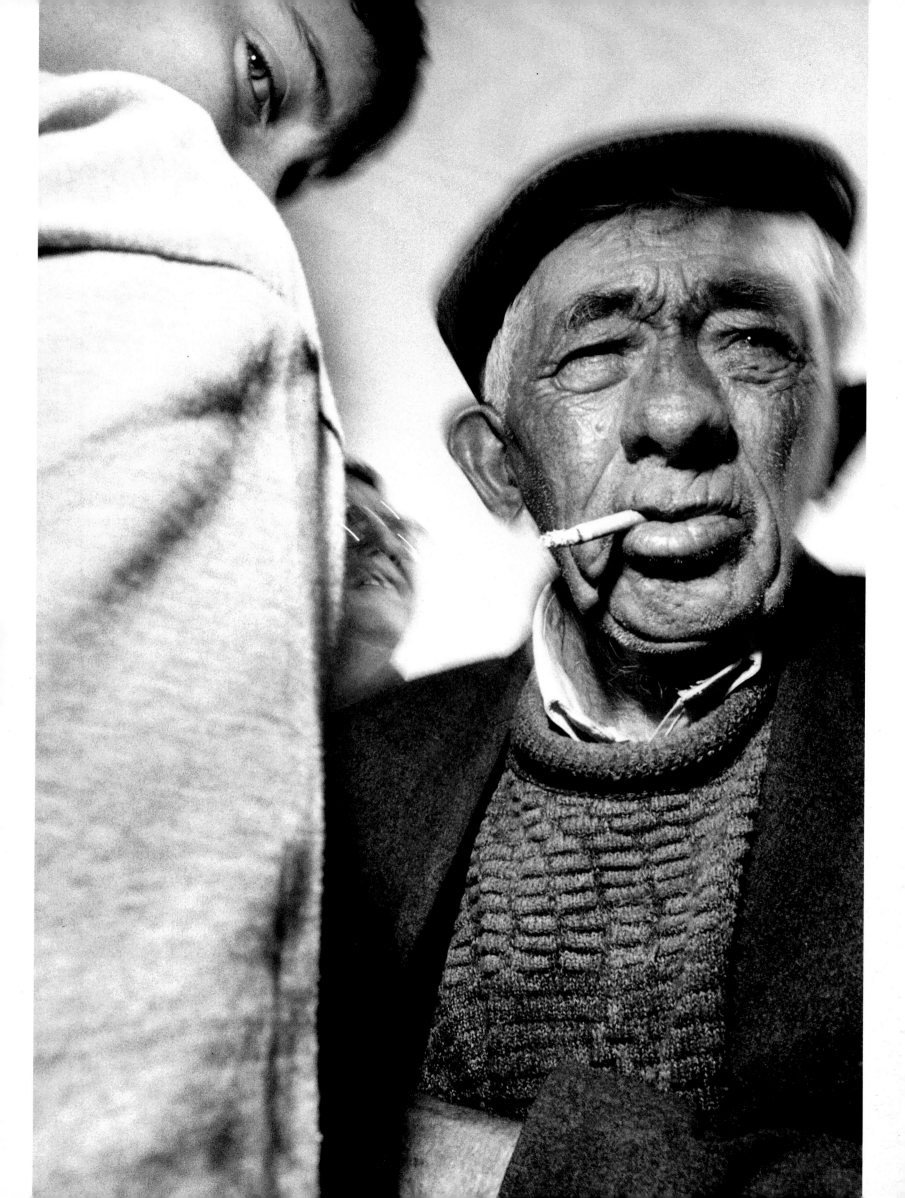

He finished his pint. A man from Cloone came up the town on a Connemara pony. He was wearing a bright red baseball cap. He sat well back surveying all. He waved at Bernie and Bernie waved back, then Bernie hailed the man from Barry's tea who gave him a lift in his van. They stopped for the musician and went on.

I saw blood this morning,
Murphy announced.
Not a good thing, boss. Best kept to yourself.
I know.
But you won't be the first to see blood
and you won't be the last.
I thought I was looking at my own blood,
he said miserably.
So it was another man's.
It was.
You were lucky.
Was I?
It could have been yours.
True.
Better it be his than yours.
I suppose so.
Well never mind, said Mangan smiling,
one day it will be your own.
That's right, said Jaimie
and he clapped his knee.
That's right, said Hugh winking. How many families are there in Heaven?
In Heaven? asked Murphy.
The very place.
I don't know.
Nine, boss. Nine families. Isn't that right Daddy.
That's correct.
So if there is nine in heaven there should have been nine on the Ark, Hugh continued.
There was only eight on the Ark,
said Murphy solidly. I stand by that.
And where did the other tribe come from?
I don't know.
Well I'll tell you!
Do.
Granard, he said, and he broke out into a low keen of merriment. Granard town.

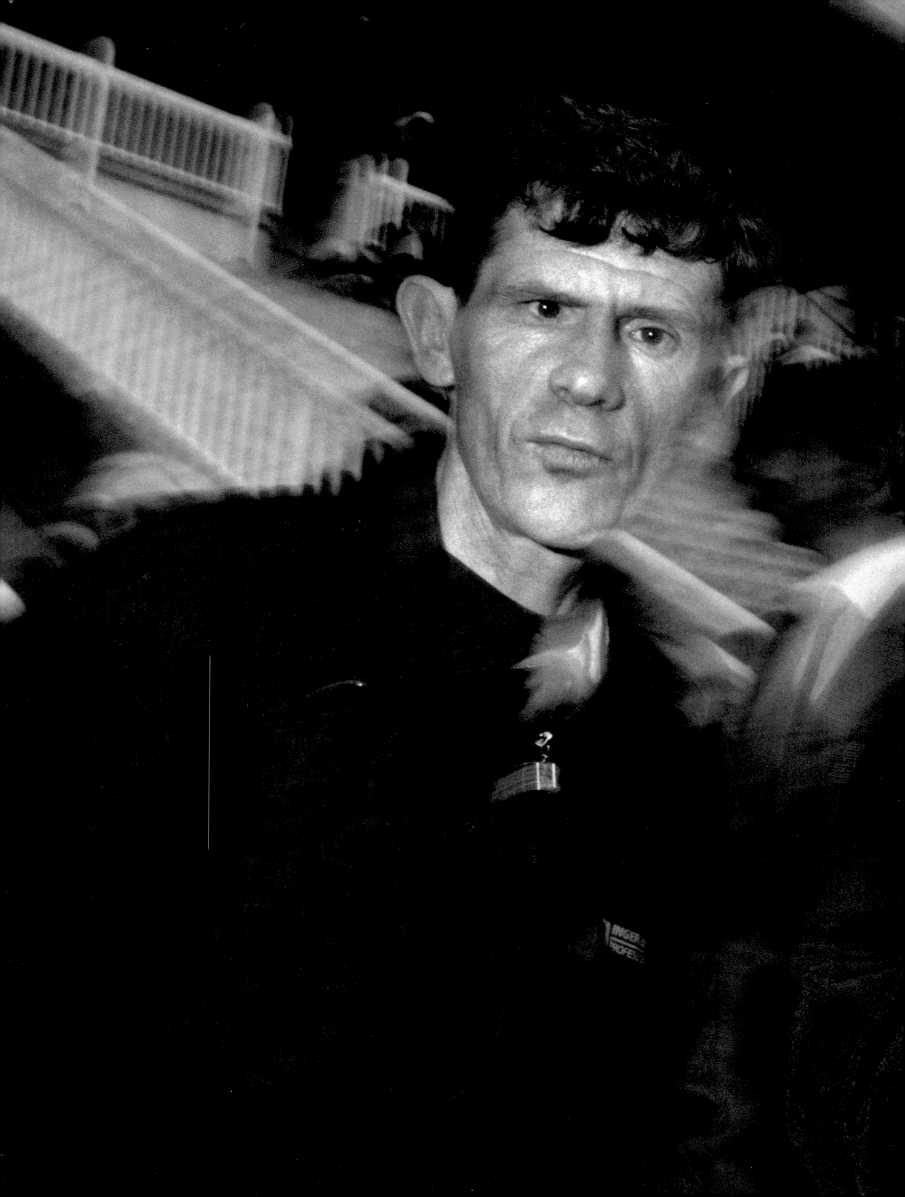

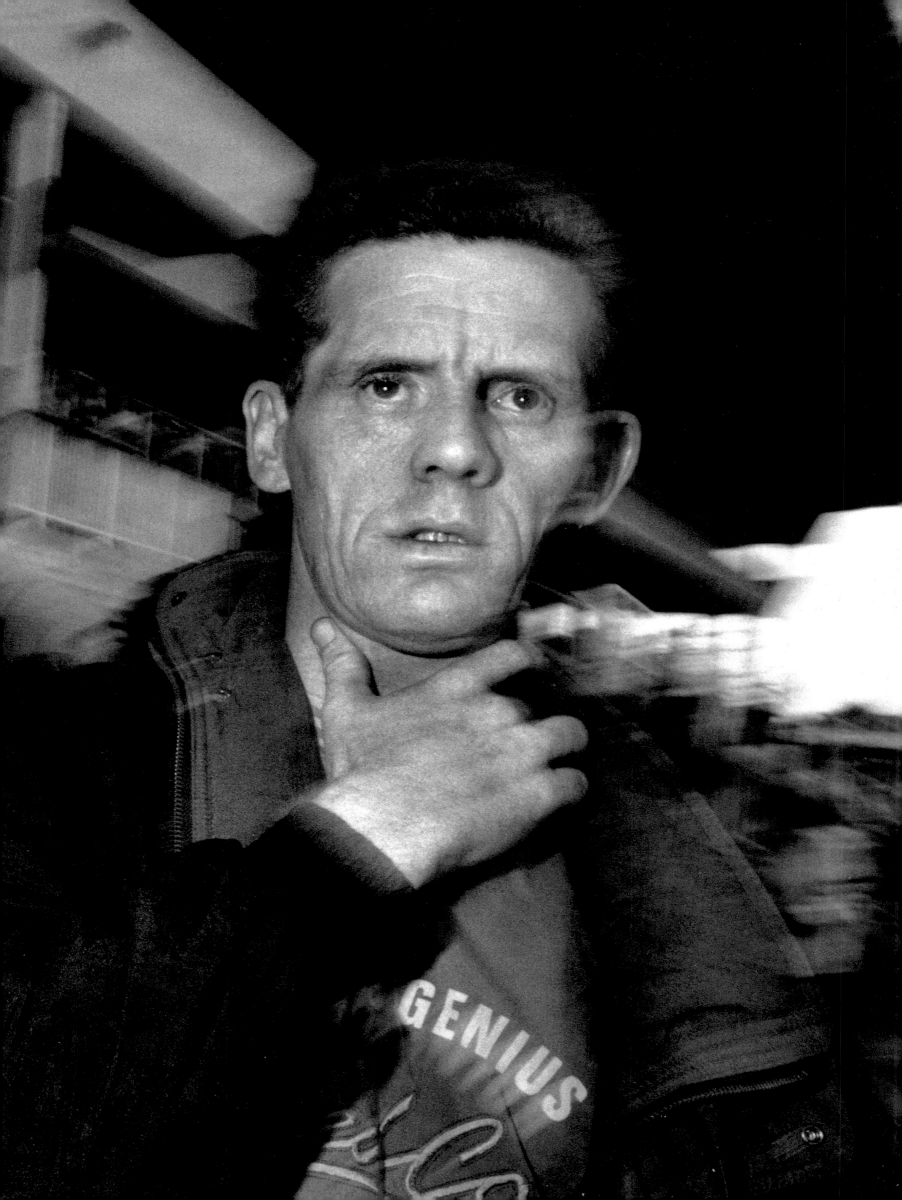

A great town for weddings,
nodded his father happily.

See that man at the bar,
asked Murphy, pointing.
I see him.
Would you believe me, asked Murphy
earnestly, if I said that the power for good or evil resides in the eye?
Simple as that sir, said Mangan,
simple as that.
Can you see any evil in mine?
I can not.
You didn't look.
I don't want to look.
But you'll agree that some
men have it in the eye.
They might have.
Yes, they have.
Hi, said Mangan, will you stop yapping.
I'm not yapping.
If you don't stop yapping -
and he looked away from him -
I'll break your face.
Murphy rose.
I thank you, he said.
He approached the bar cautiously.
I'm not alone in what I think, he said.
I'm glad for you, said Tim Pat.
There's others see what I see.
Good for you.

We're talking here of sleepless nights, Mr Murphy, said Aggie.
I never had them.

You're the lucky man. There I am all night, tossing and turning, continued Aggie. And then at last you get one good beautiful thought and you think you're away, this is it now, I'm for bye-byes, at last, at long last oh God in heaven, **it's lovely just losing yourself**, not a care in the world and you think it's gone on for ages but when you look at the clock only a minute has passed. It's terrible. Terrible.

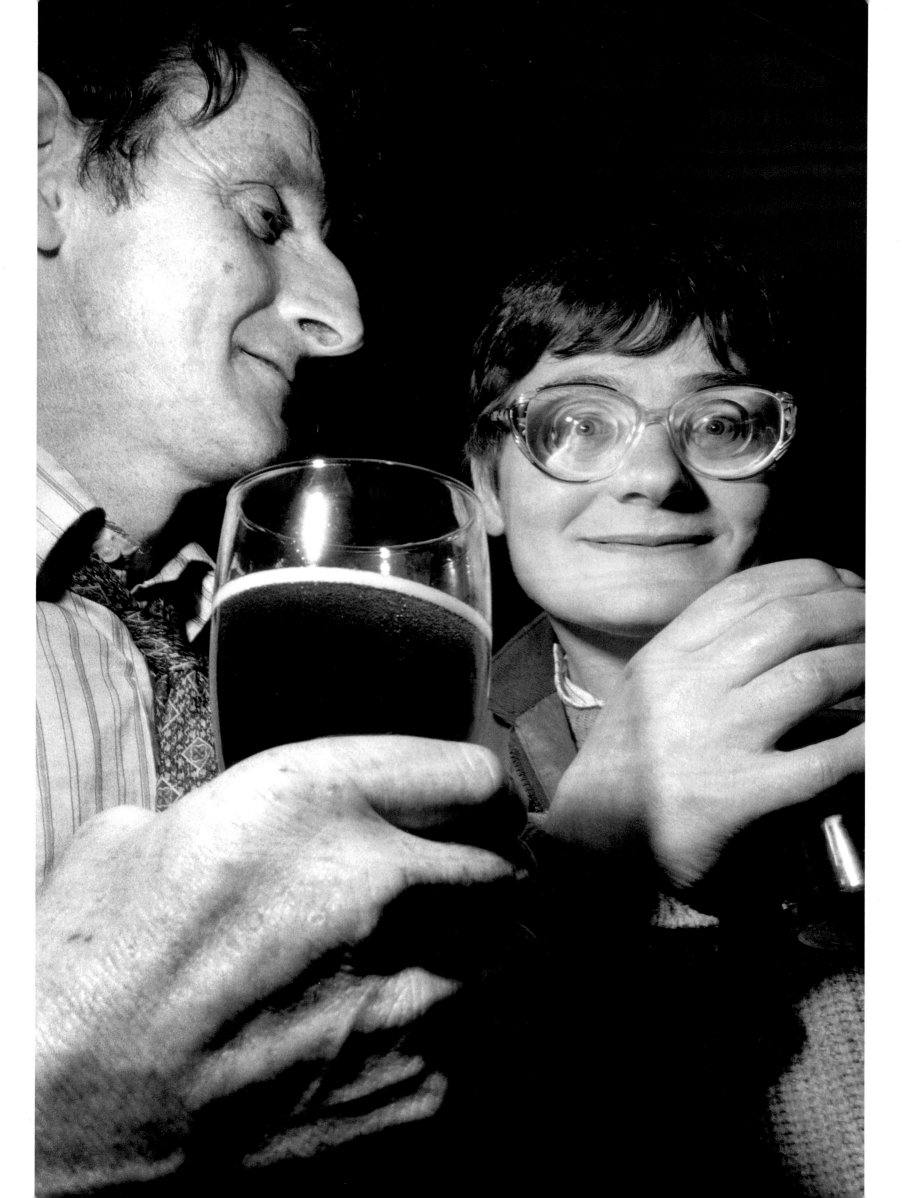

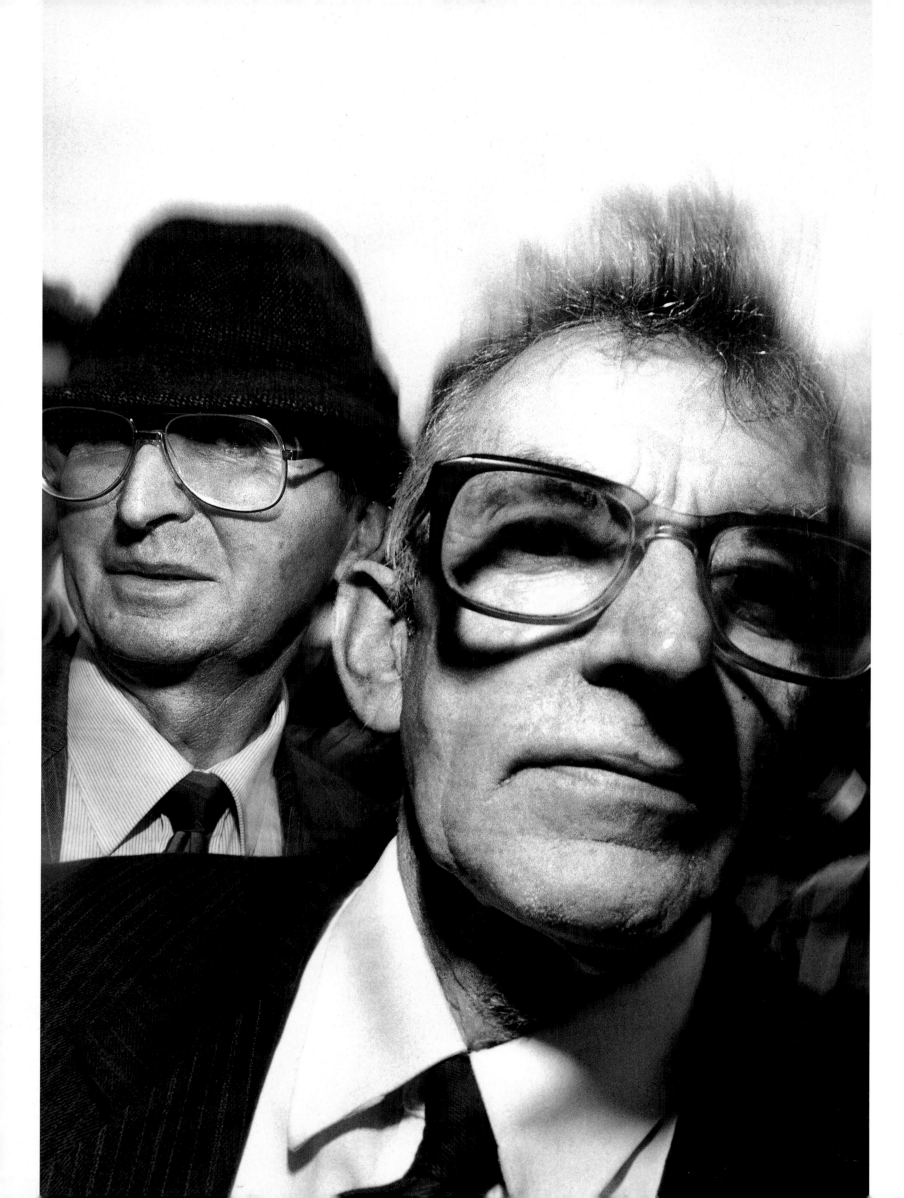

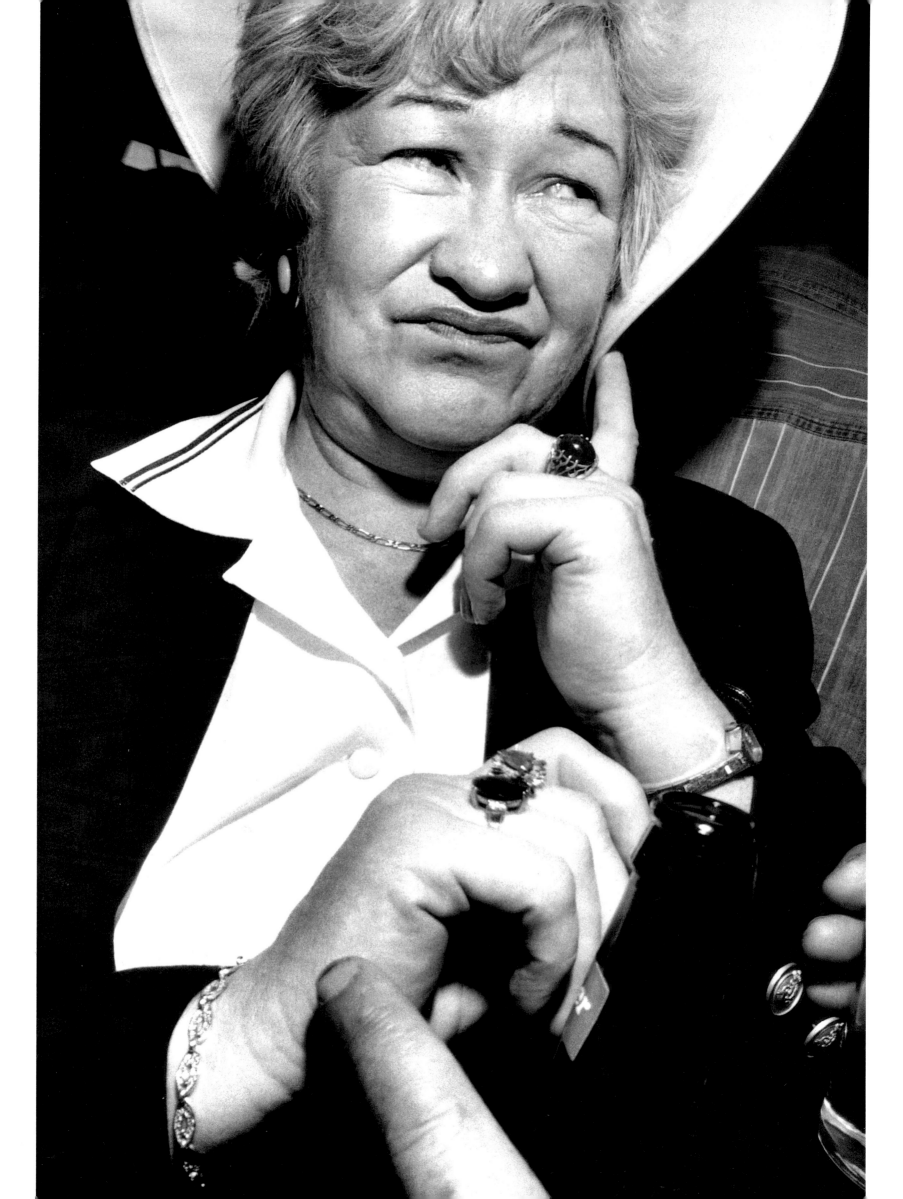

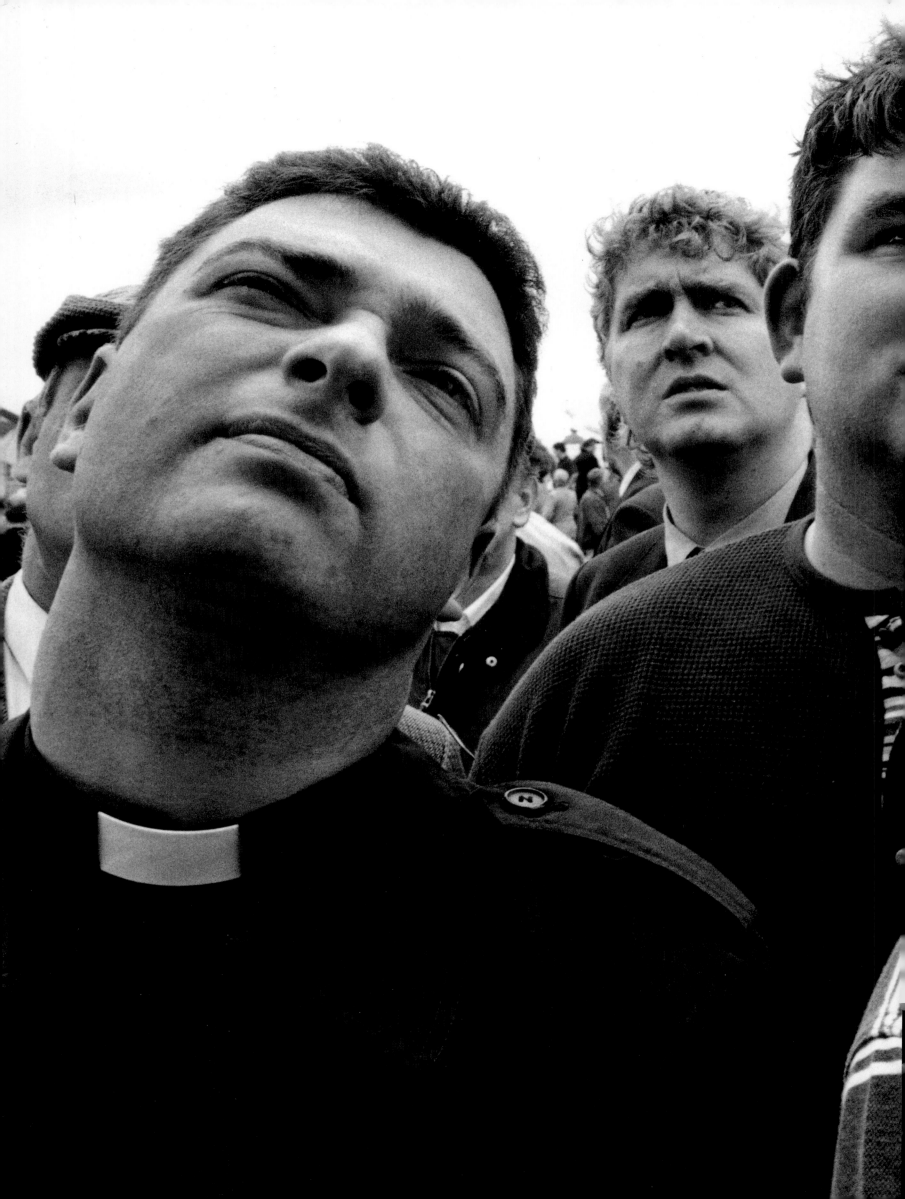

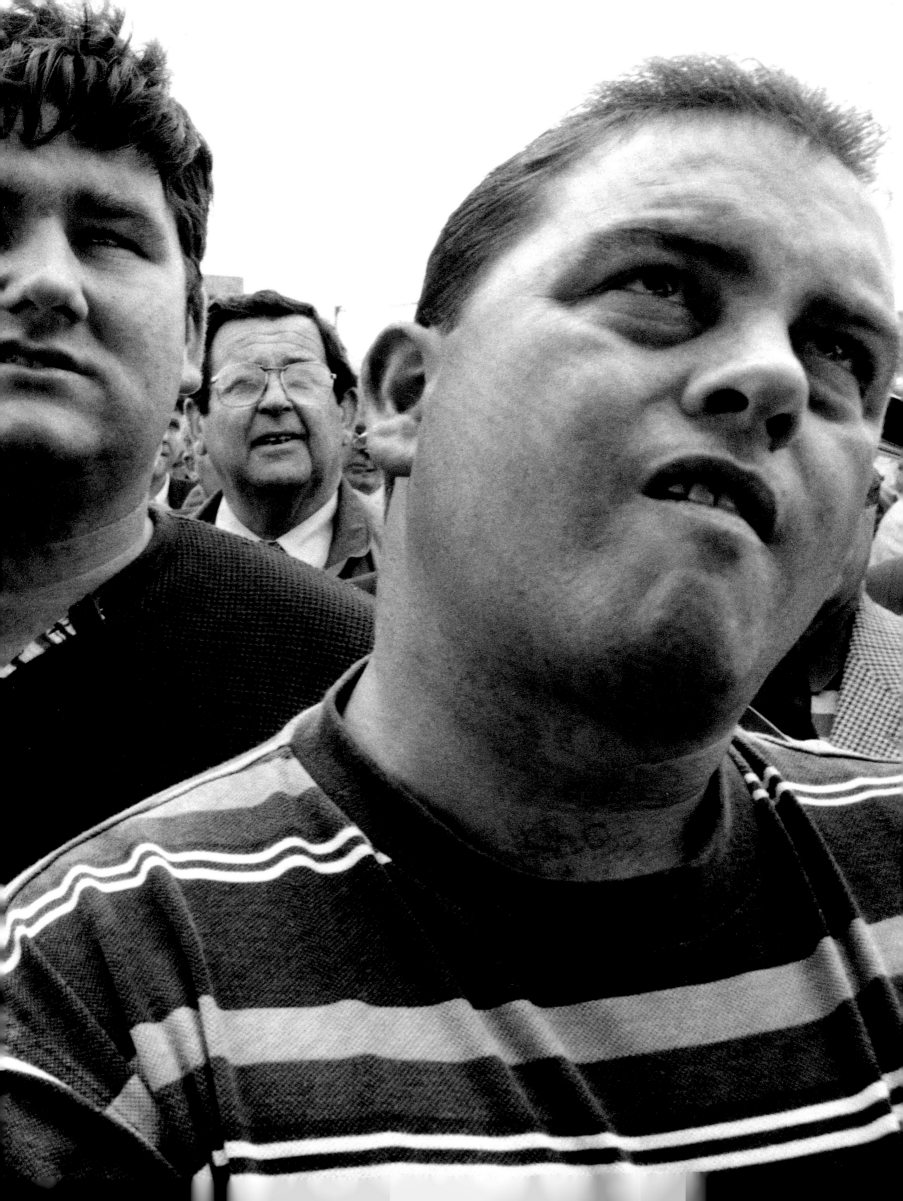

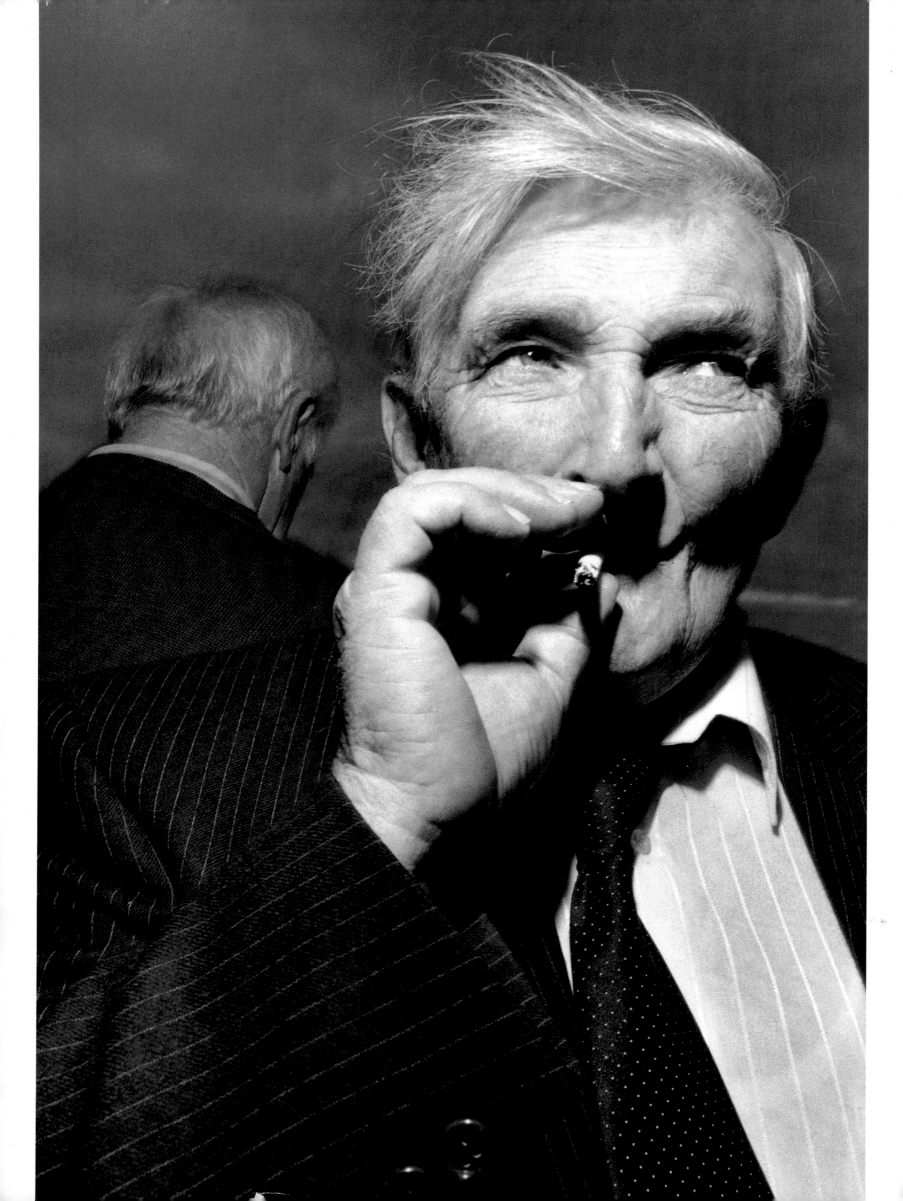

A pint of **Smithwicks**, said Murphy.

Right so, said Aggie.

He propped himself by Banks.

You were seen, he whispered confidentially.

Be who?

What fucking business is it of yours?

The gas heater popped. Murphy sat himself back on his chair and shook his shoulders.

La-de-da, he said.

Mc Donald came straight in and went to the bar for cigars. The lapel of his jacket was decorated with the membership tags of various racecourses. He dropped his binoculars on the counter.

Cigars, Mr Mc Donald?

The very thing Aggie.

So have you anything?

I heard a whisper about Ivanhoe.

Ivanhoe, said Murphy, is class.

A decent animal, said Mc Donald. He clipped the cigars into his top pocket and took out a handkerchief and polished his shoe, straightened up and nodded at Murphy.

You want to come with me Peadar.

Not today, Mr Mc Donald, said Murphy.

Are you sure?

I don't think so.

Well you're welcome.

Not today, I don't think. Later maybe.

Mc Donald strode over to the Gypsies.

Mister Mangan, he said.

Mister Mc Donald.

He strode over to Murphy and put his mouth to his ear.

You'd be better off out of the pub, he whispered.

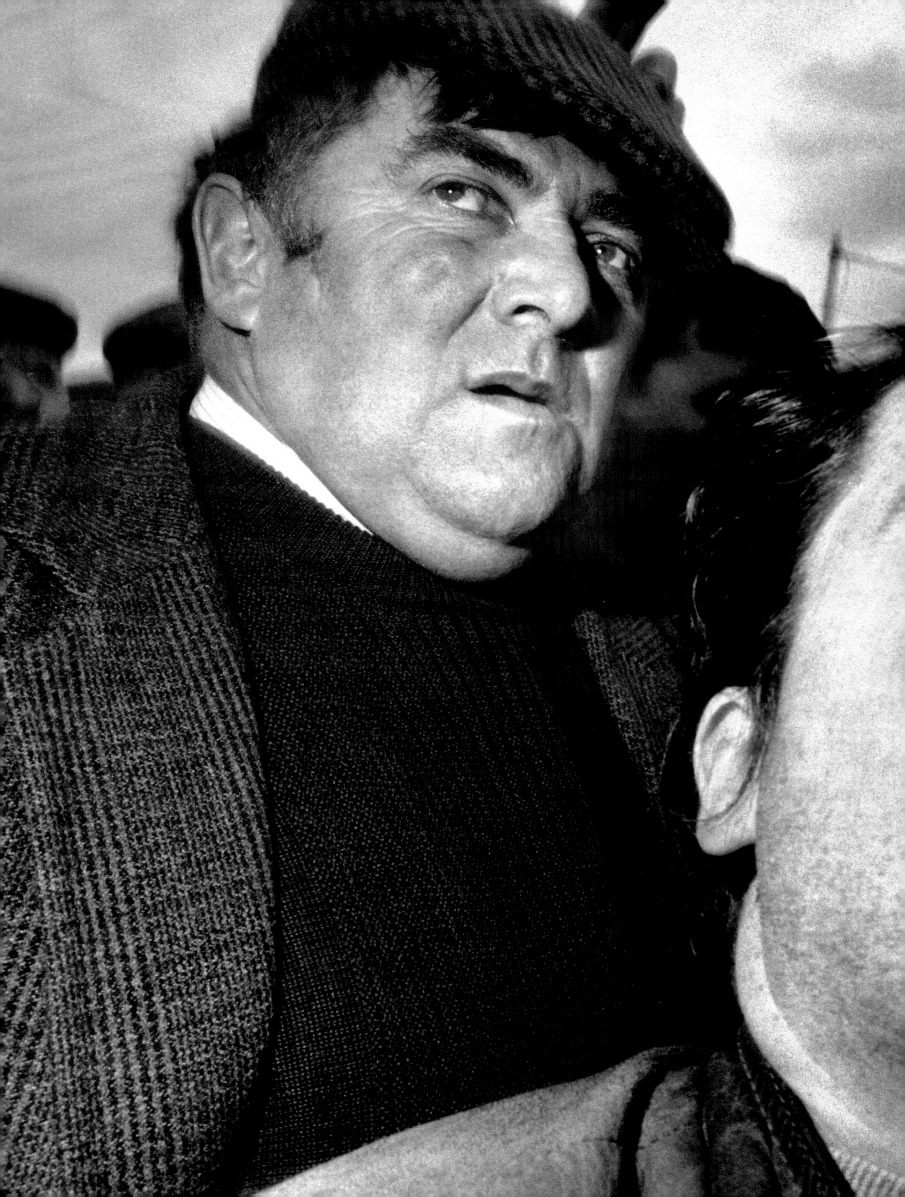

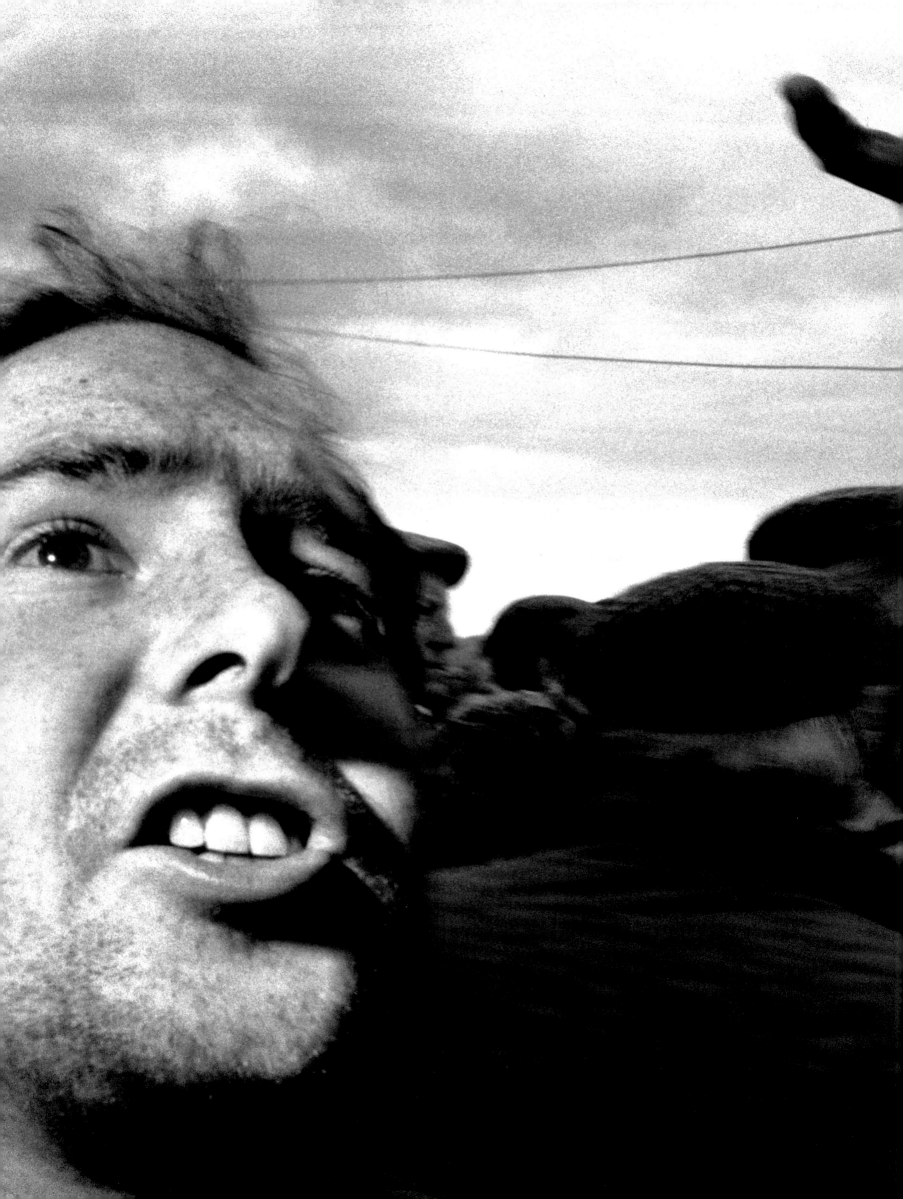

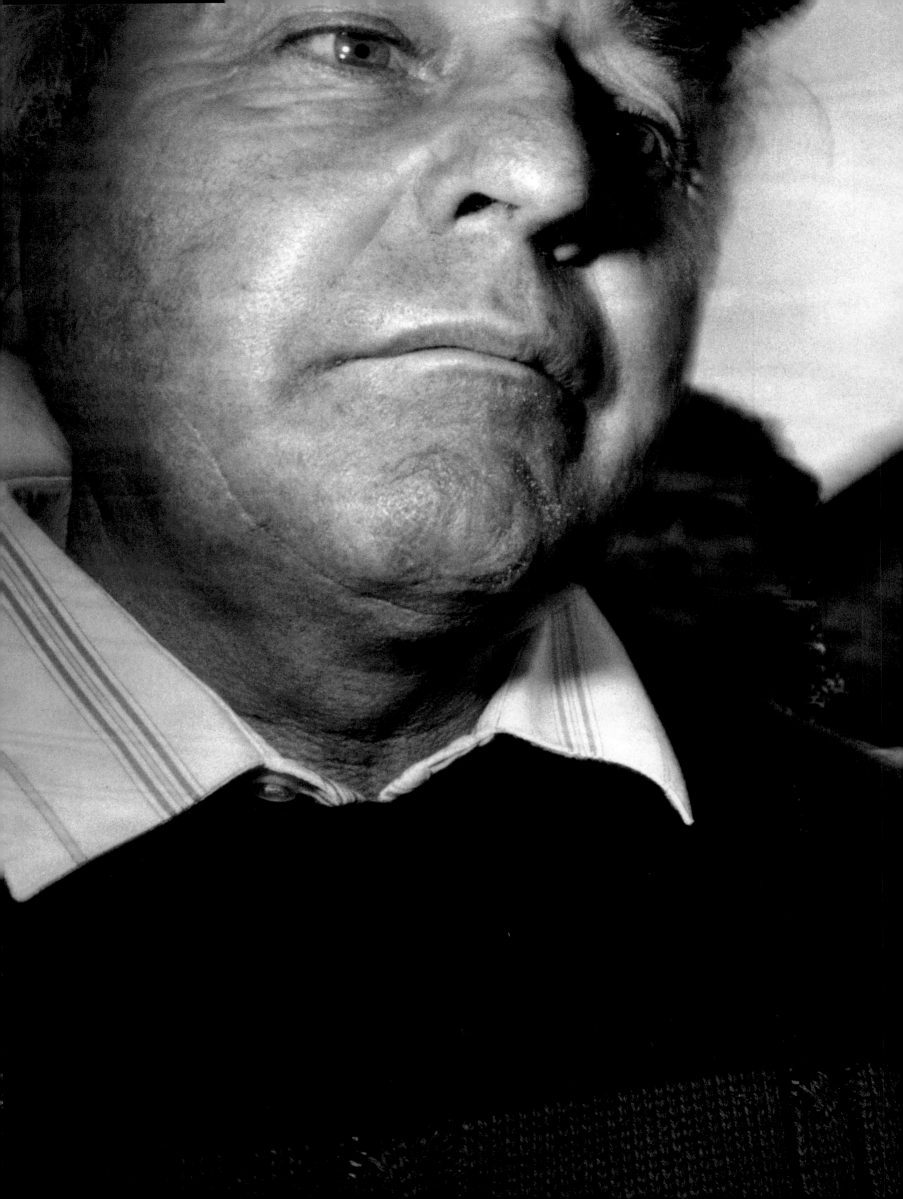

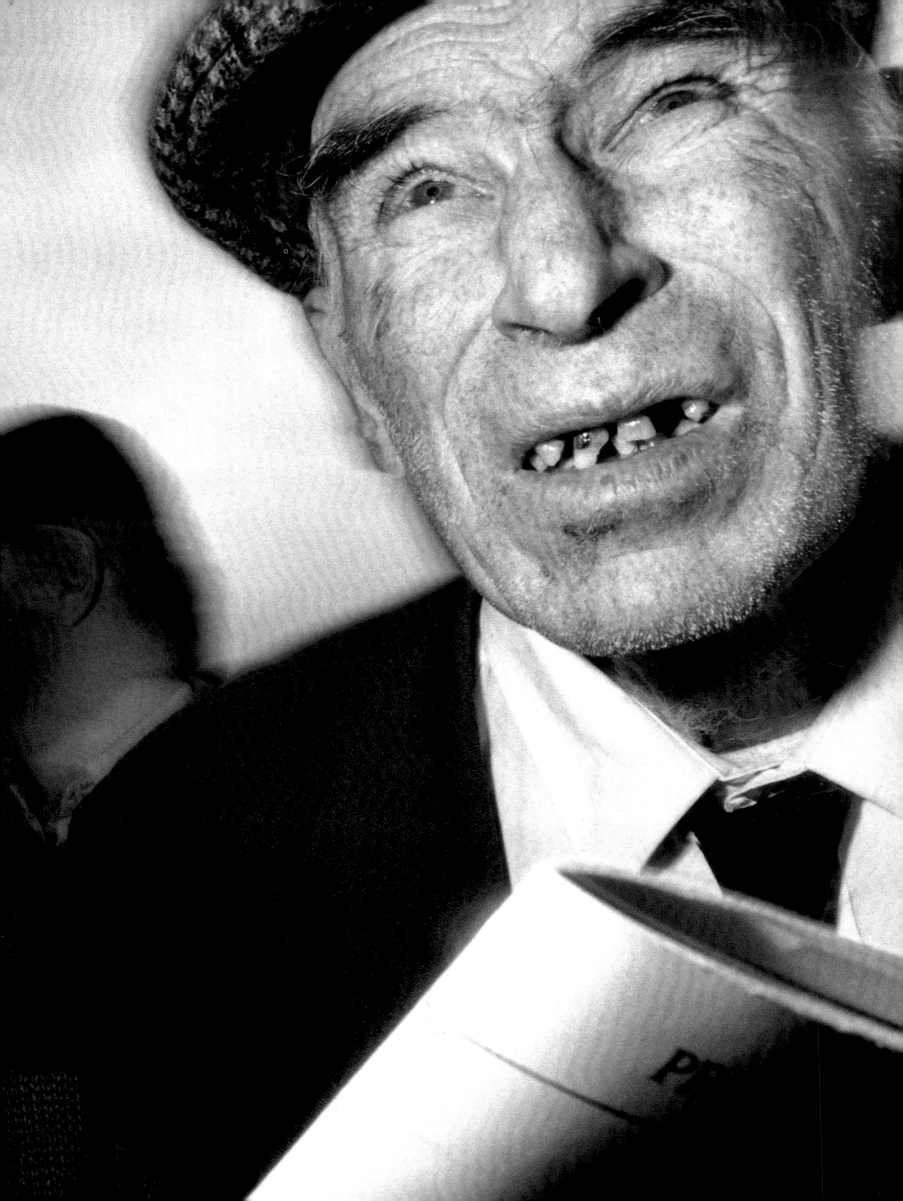

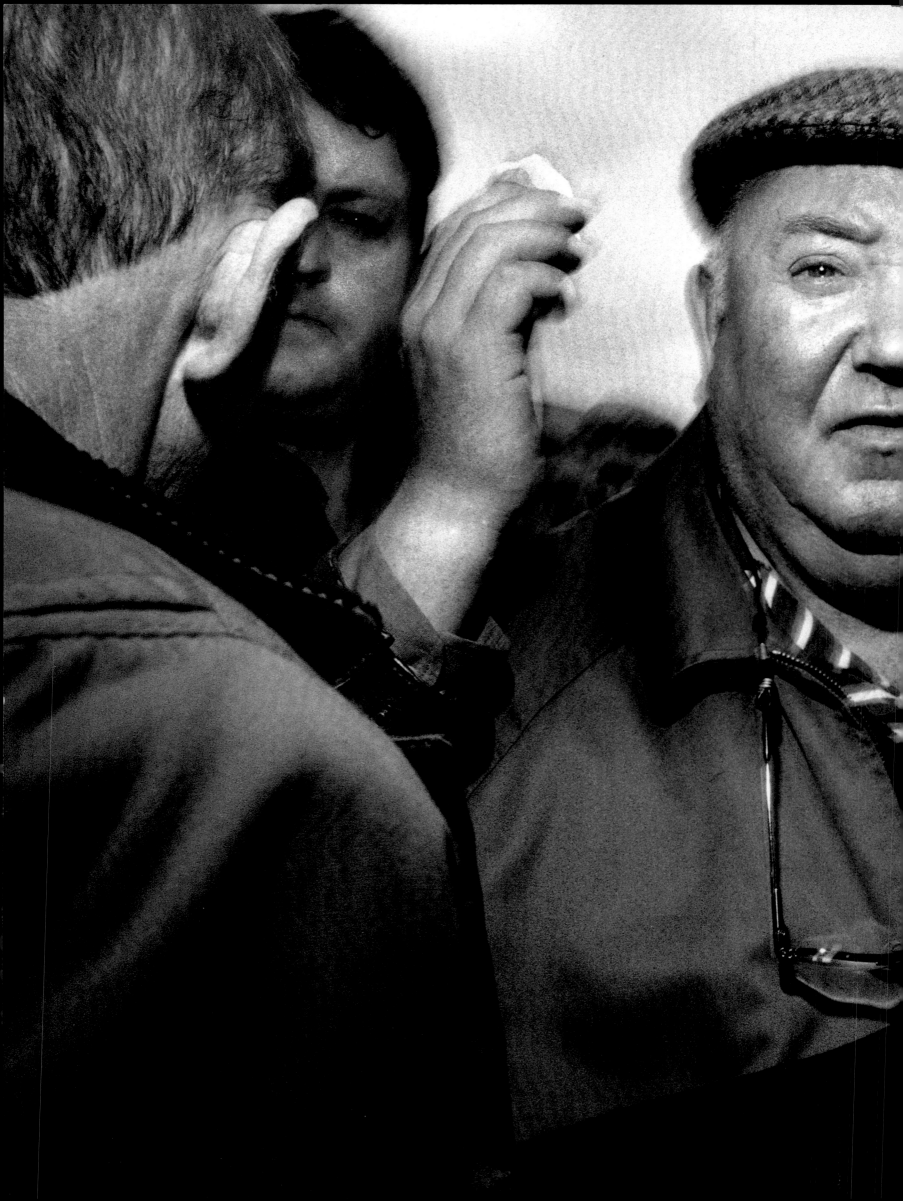

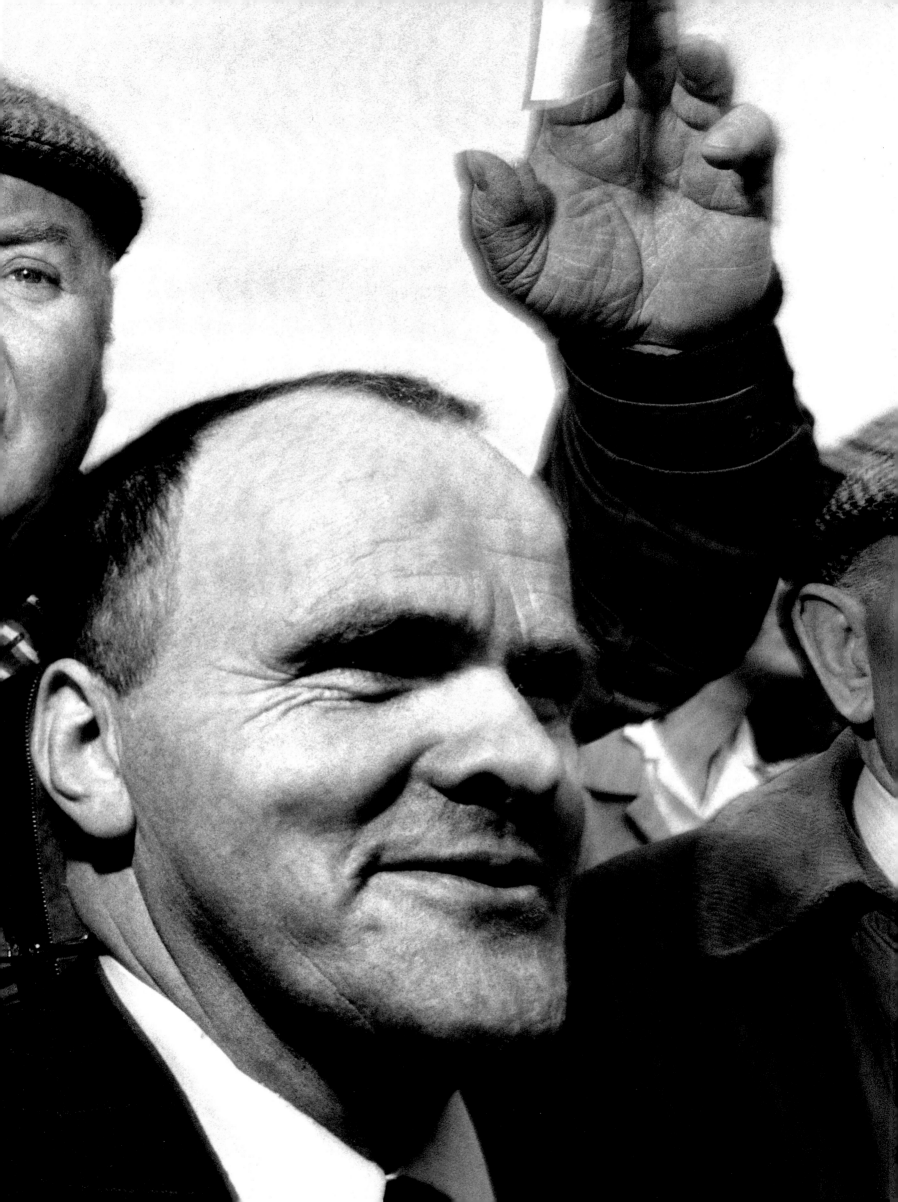

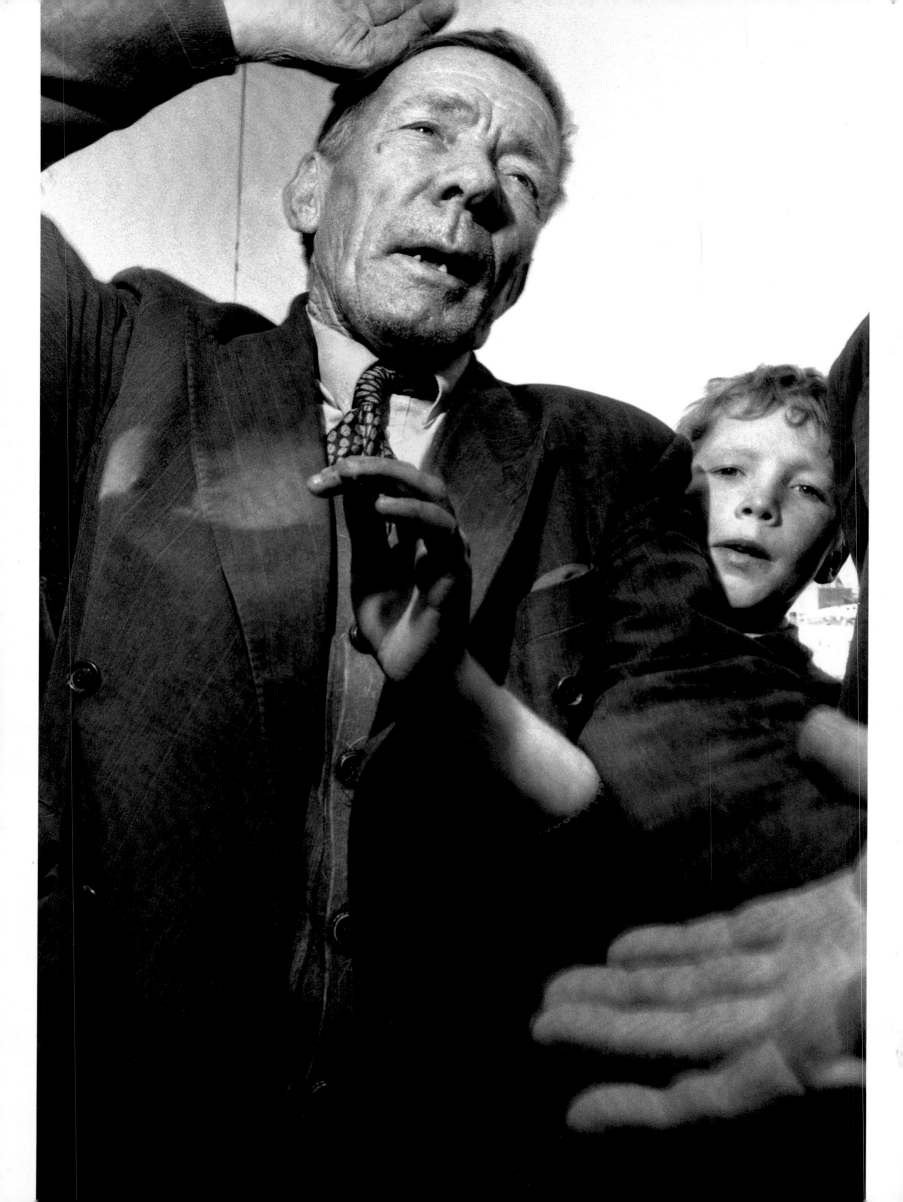

I know that, whispered Murphy.
Good luck so, said Mc Donald and he left.
A grand man, said Murphy.
And why don't you go with him, asked Tim Pat.
Not today, said Murphy.
Go on, said Aggie.
Do you think I should, he asked.
I do.
He jumped to his feet and out the door.
Peace now for a while, said Aggie.

She hit the TV and the Alps came on. She hit another button and it was rock. She hit another button and it was darkness again. Then the door opened and Murphy returned.

Not to-day, he said.
Why is that?
I don't know.

Mc Donald stopped the car on the bridge. He got out and looked down at the river. He lit a cigar. At first he couldn't be sure. So he took out the binoculars and trained them down water. Then he saw a young trout in the shallows. He kept coming and going from splashes of dark sky, out into the brightness and gone.

Mc Donald tied his laces again.

He looked at his watch—three minutes to go. He walked the bridge from East to West then back again. He sat on the passenger seat with the door of the car open and read the deaths under the letter M in the Independent. Then he turned to the horses. A fine drizzle fell.

He closed all doors and sat a while with the steering wheel in his hands. He viewed the wet windscreen. Some memory made him tremble. He blew his nose into a tissue and listened to the rain on the roof of the car. **It came down with a crack then went suddenly quiet.** The car grew warm and lonely. He pressed the butt of the cigar into the ashtray and snapped it shut.

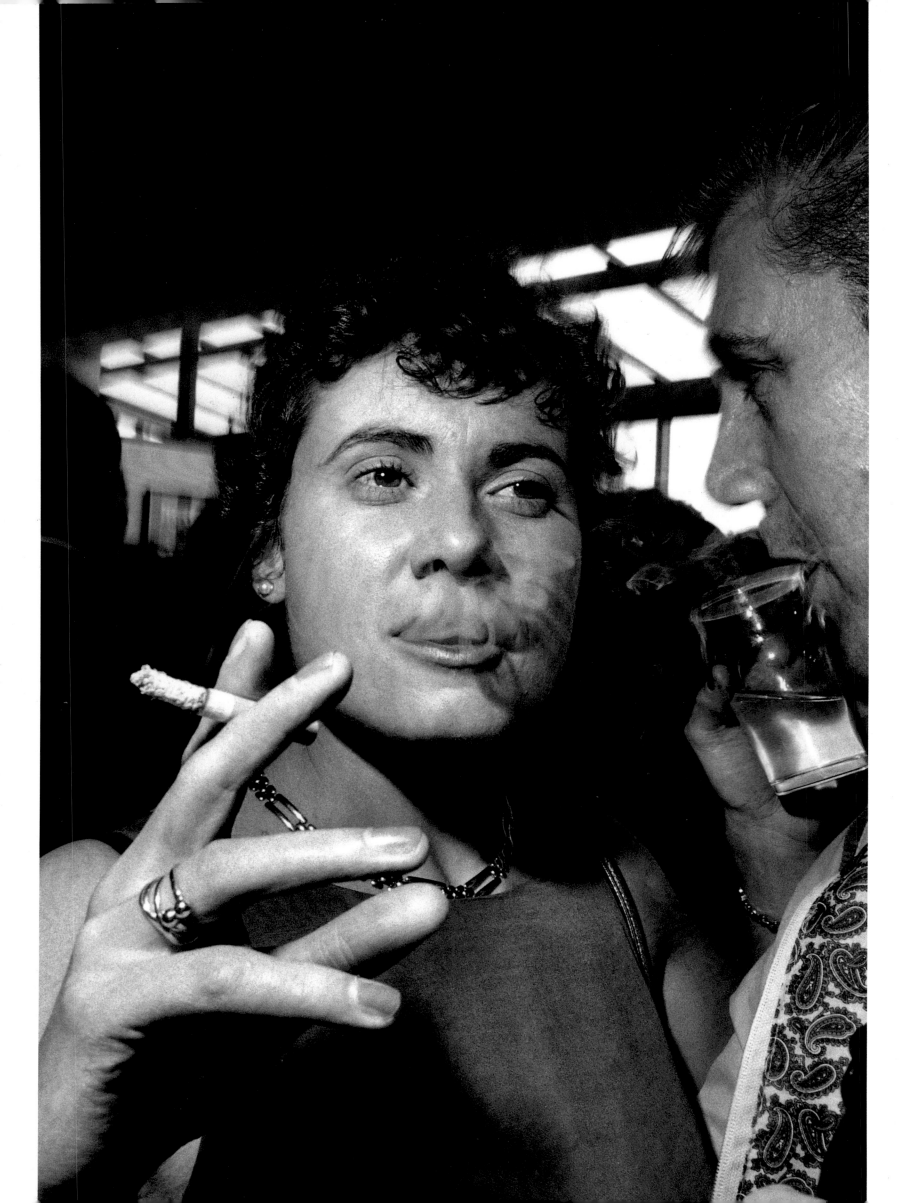

I know that, whispered Murphy.
Good luck so, said Mc Donald and he left.
A grand man, said Murphy.
And why don't you go with him, asked Tim Pat.
Not today, said Murphy.
Go on, said Aggie.
Do you think I should, he asked.
I do.
He jumped to his feet and out the door.
Peace now for a while, said Aggie.

She hit the TV and the Alps came on. She hit another button and it was rock. She hit another button and it was darkness again. Then the door opened and Murphy returned.

Not to-day, he said.
Why is that?
I don't know.

Mc Donald stopped the car on the bridge. He got out and looked down at the river. He lit a cigar. At first he couldn't be sure. So he took out the binoculars and trained them down water. Then he saw a young trout in the shallows. He kept coming and going from splashes of dark sky, out into the brightness and gone.

Mc Donald tied his laces again.

He looked at his watch—three minutes to go. He walked the bridge from East to West then back again. He sat on the passenger seat with the door of the car open and read the deaths under the letter M in the Independent. Then he turned to the horses. A fine drizzle fell.

He closed all doors and sat a while with the steering wheel in his hands. He viewed the wet windscreen. Some memory made him tremble. He blew his nose into a tissue and listened to the rain on the roof of the car. **It came down with a crack then went suddenly quiet.** The car grew warm and lonely. He pressed the butt of the cigar into the ashtray and snapped it shut.

That's it, he said.

He turned the ignition key.

Right, he said and he drove off at last towards whatever was ahead.

Three strangers entered Langs and lay their rucksacks, an accordion and a bodhran down on the forum by the low window.

They left the door open behind them. The sound of horses and tractors echoed in.

Dun an doras, said Murphy.

I am sorry, said the girl, my English is not so good.

Neither is his Irish, said Tim Pat. He's saying You left the door open.

I'm saying Close the door, said Murphy, to be exact.

Balls.

She tried turning the latch but couldn't.

I'll get the blasted door, said Tim Pat. The latch I'm afraid catches the foreigner.

Oh.

He resumed his place.

The girl called three pints of Guiness please, then began counting her money. Murphy rose with

a scandalous eye.

Are you Germans or what? he asked.

I am East Germany, said one tousled lad and he extended his hand. Murphy dropped a soft
paw onto the palm.

So they let youse out from behind the wall.

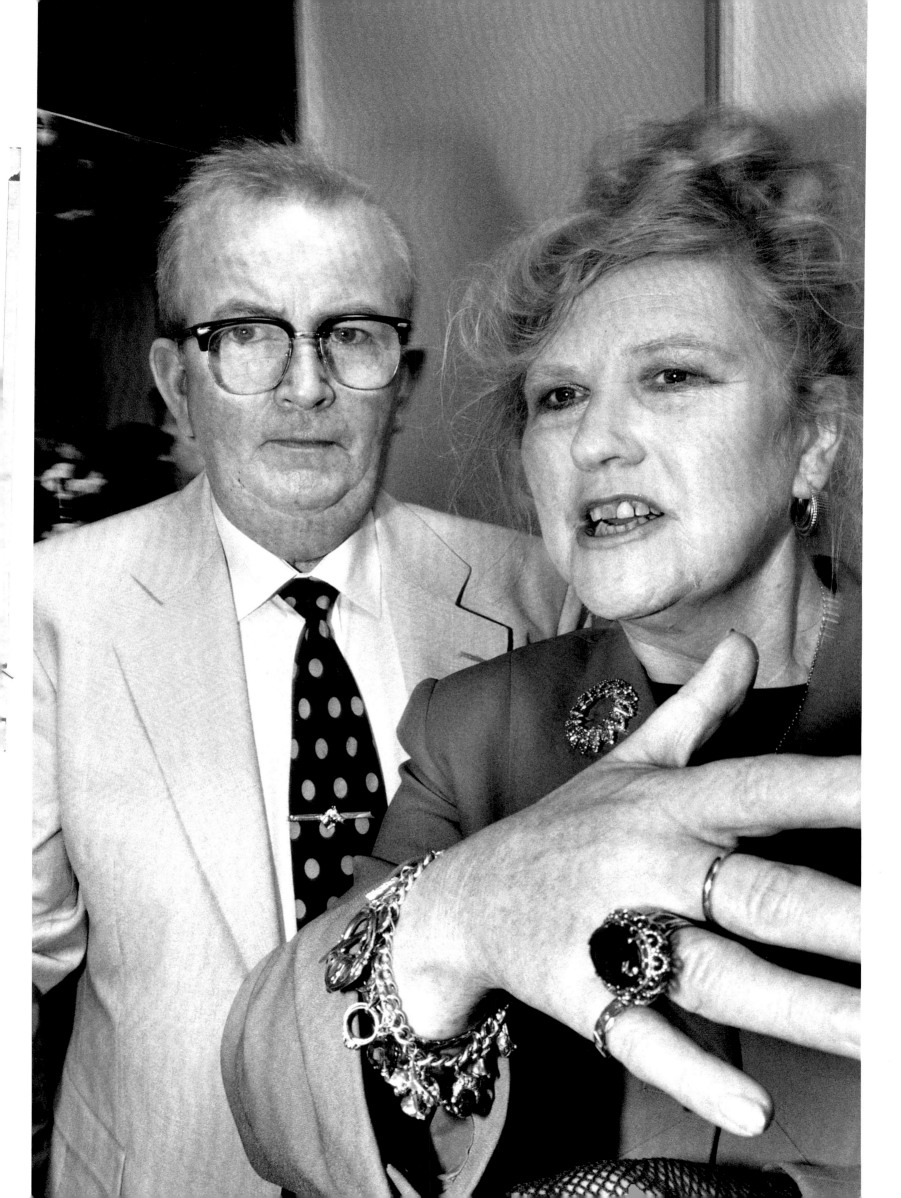

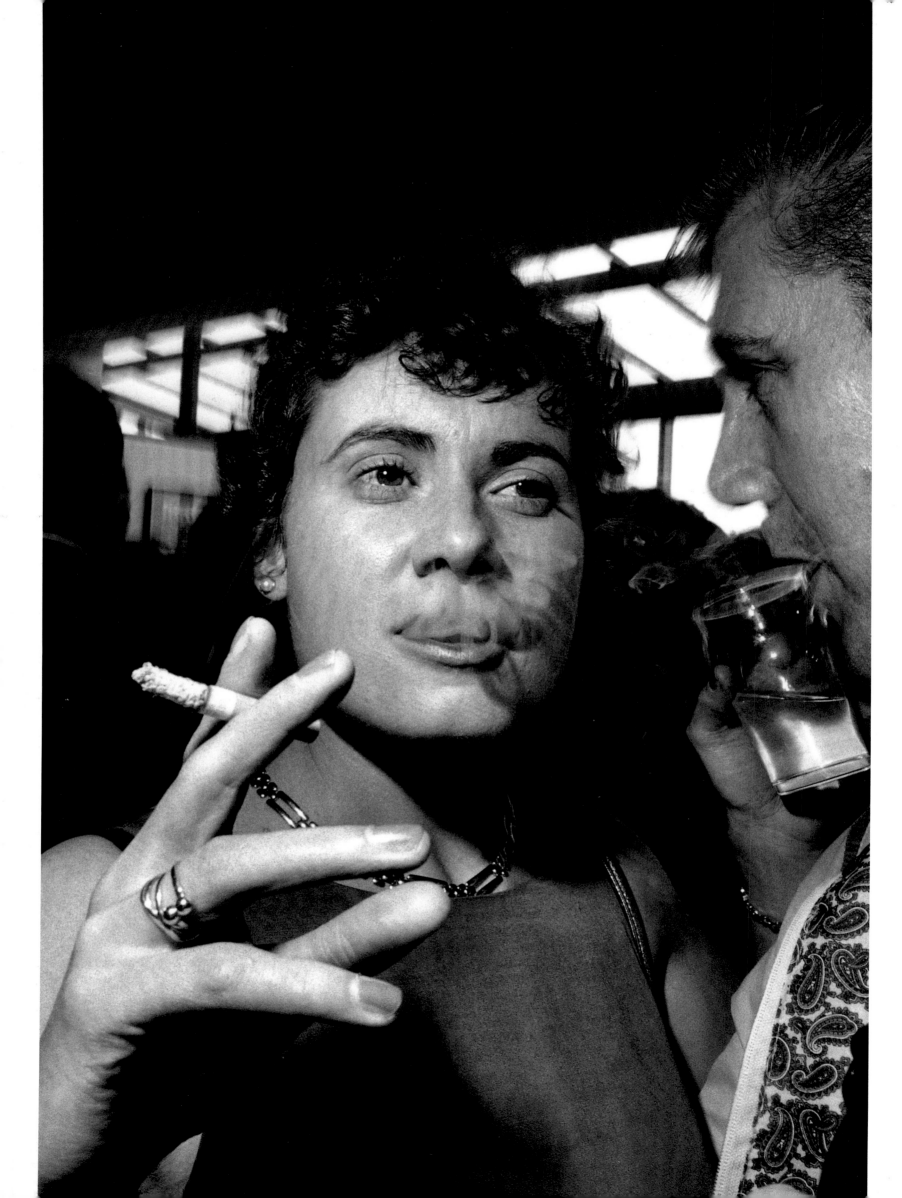

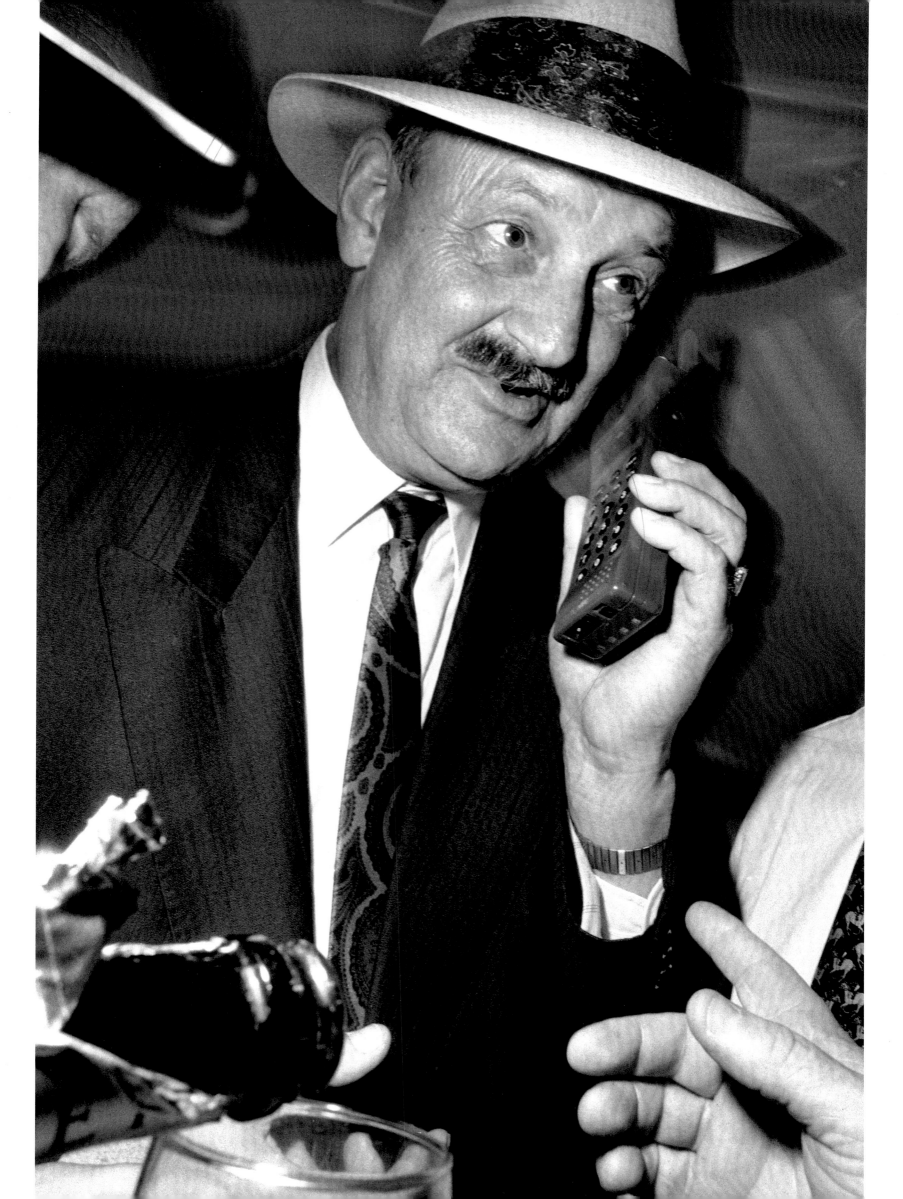

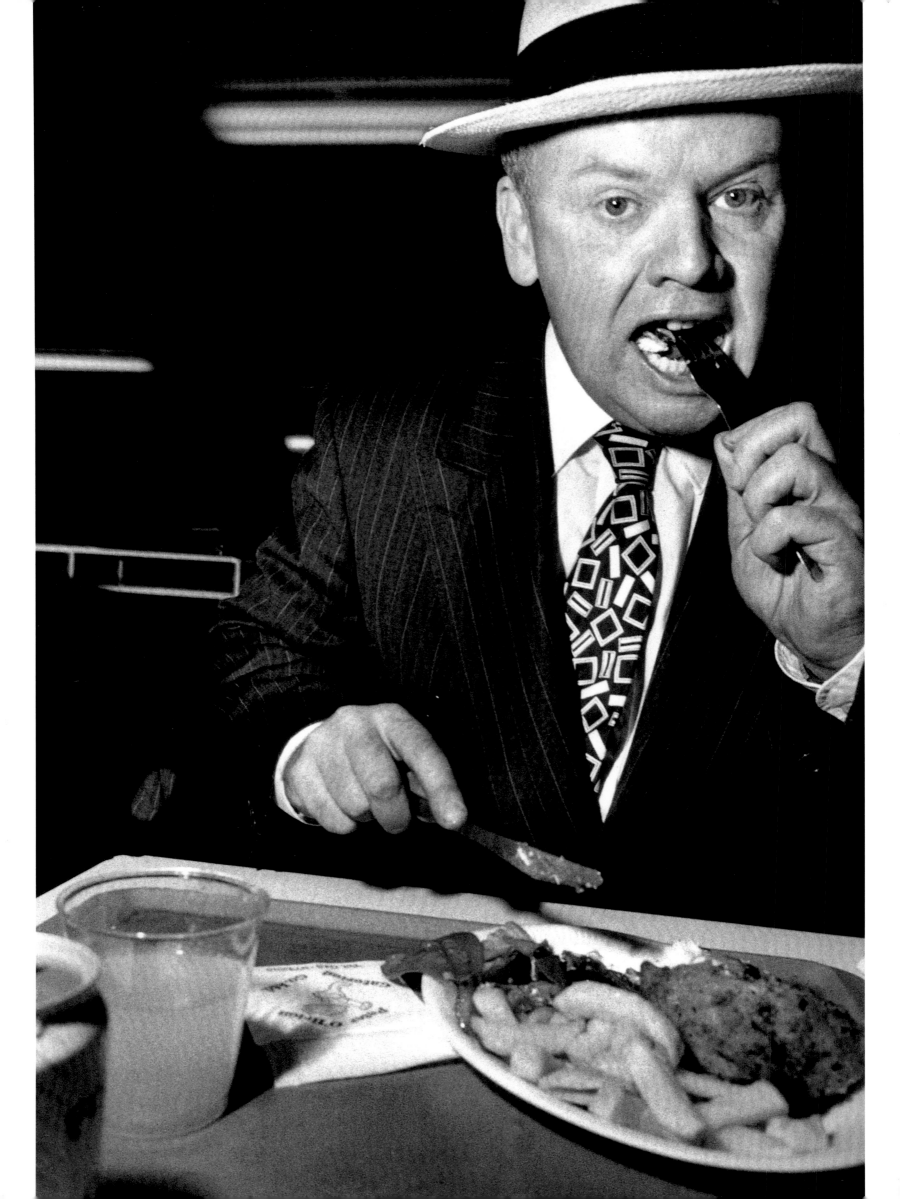

My friends are from the Vest.

What?

Ve have problem I think.

You might swear, said Tim Pat.

Don't talk to him, said Murphy, don't even register his presence.

You speak Irish, no?

Not in his nanny, said Tim Pat.

The door flew open again. In stepped two young farmers from the locality.

He's not here, said one.

He's not, said the other.

Was Mattie Sheridan in?

No, said Aggie.

Your woman is going wild looking for him.

Well he's not here.

He's not here. He looked to his friend. Will we stop for one?

No. We'll go on.

We will. Thanks a lot.

The pub went quiet. The strangers counted money onto the bar and the girl asked for crisps.

You have crisps? she asked as she put a camera onto the bar.

No, said Aggie, but I have rhubarb tart.

Do you mind, said the girl and she trained the camera on Murphy. He gasped,
then shook his head.

In the Irish House a card game in a bedroom ended and the poker players came downstairs.

Wondrous, quoted Murphy, is the robin

there singing to us and the cat escaped from us.

Please? asked the girl.

Pass no heed on him, said Tim Pat.

Mr Banks? said Murphy in a plaintive voice.

Yes?

Mr. Banks, he said again.

Yes! shouted Tim Pat.

Every morning I step in here you're over there, laughed Murphy.

Well if you weren't here you wouldn't see me.

I would see you—and Murphy drew a finger to his forehead

and saluted—even if you weren't there.

Jesus.

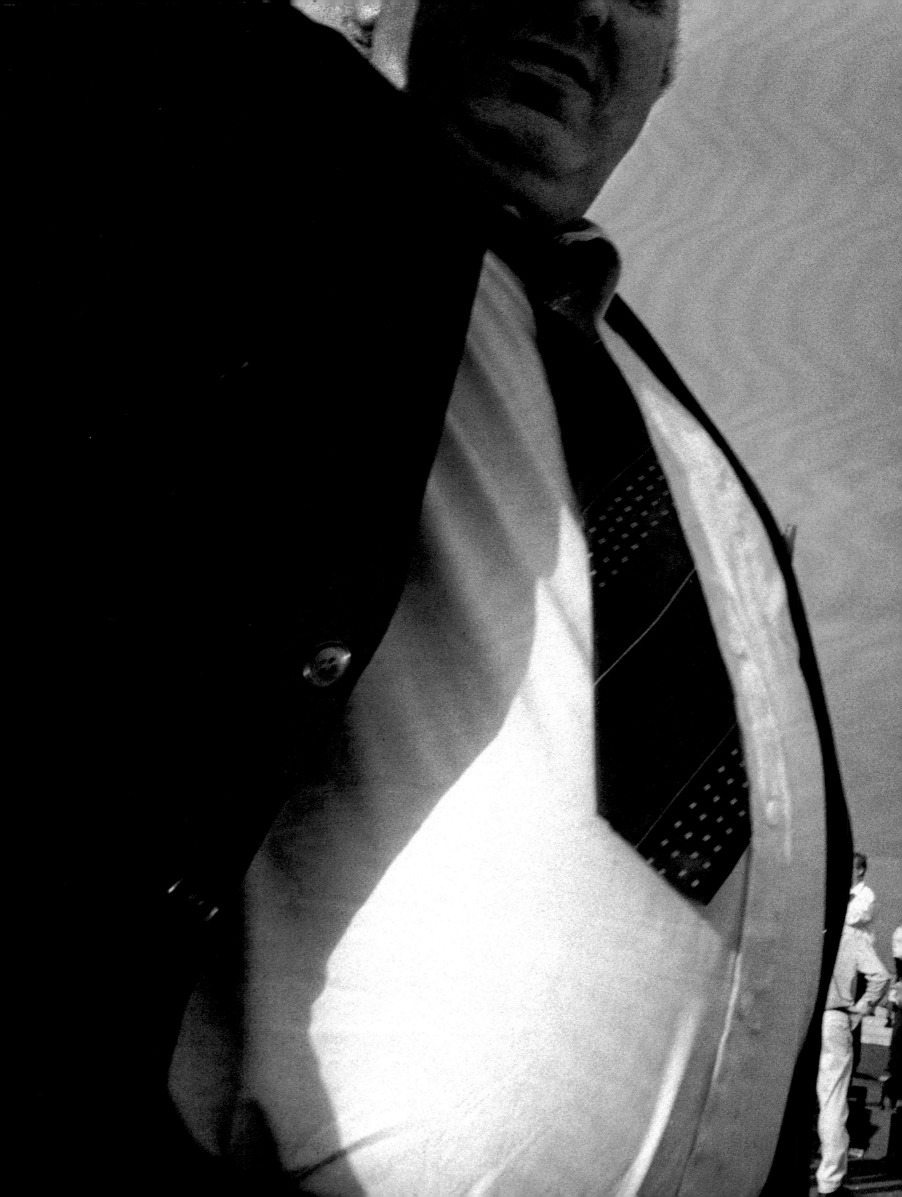

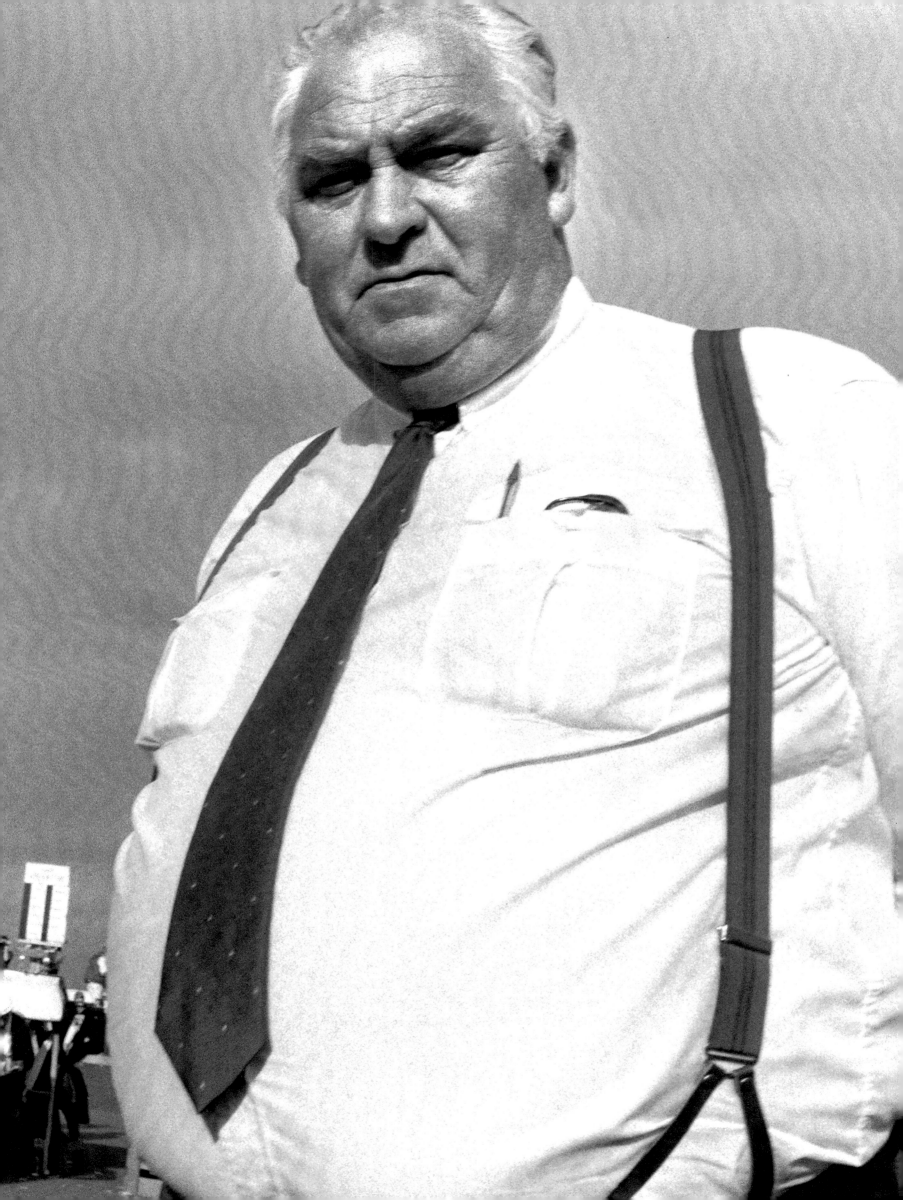

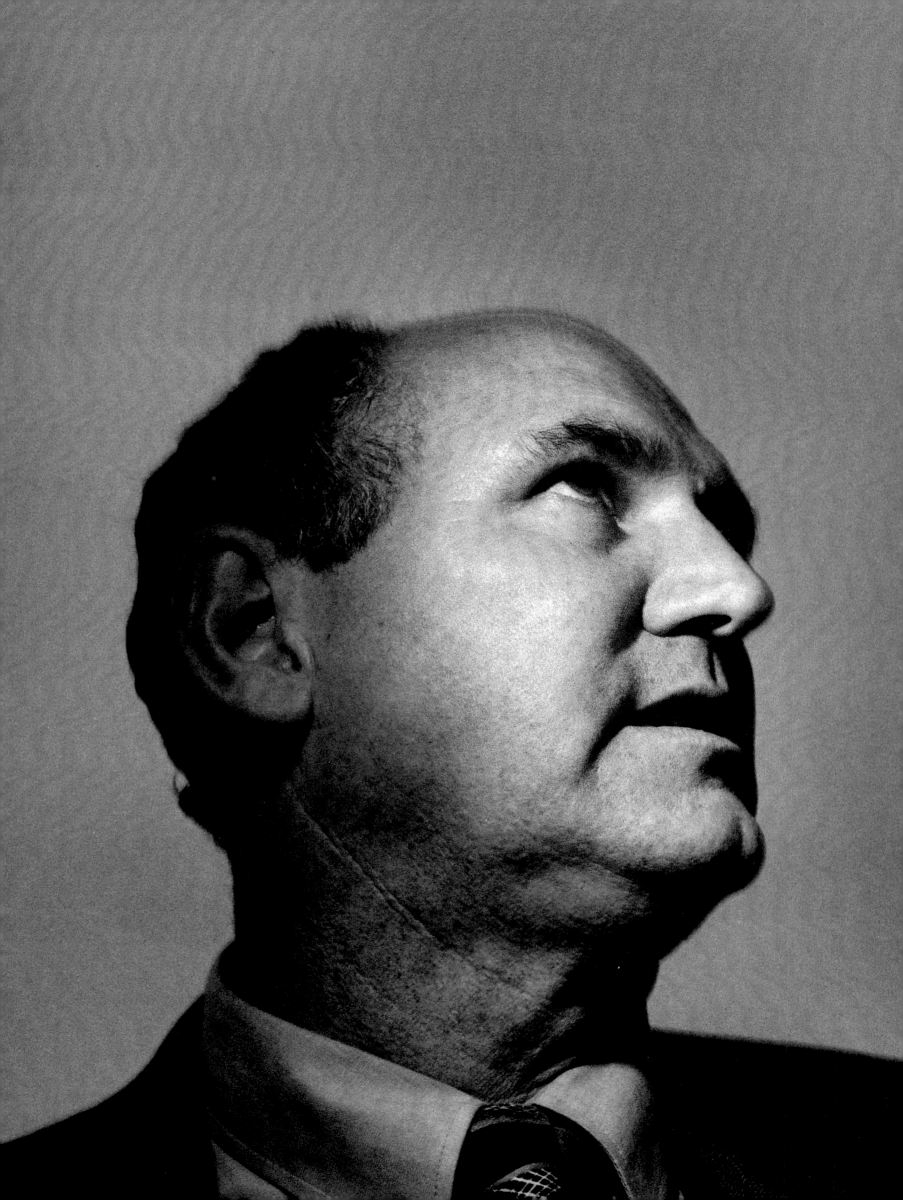

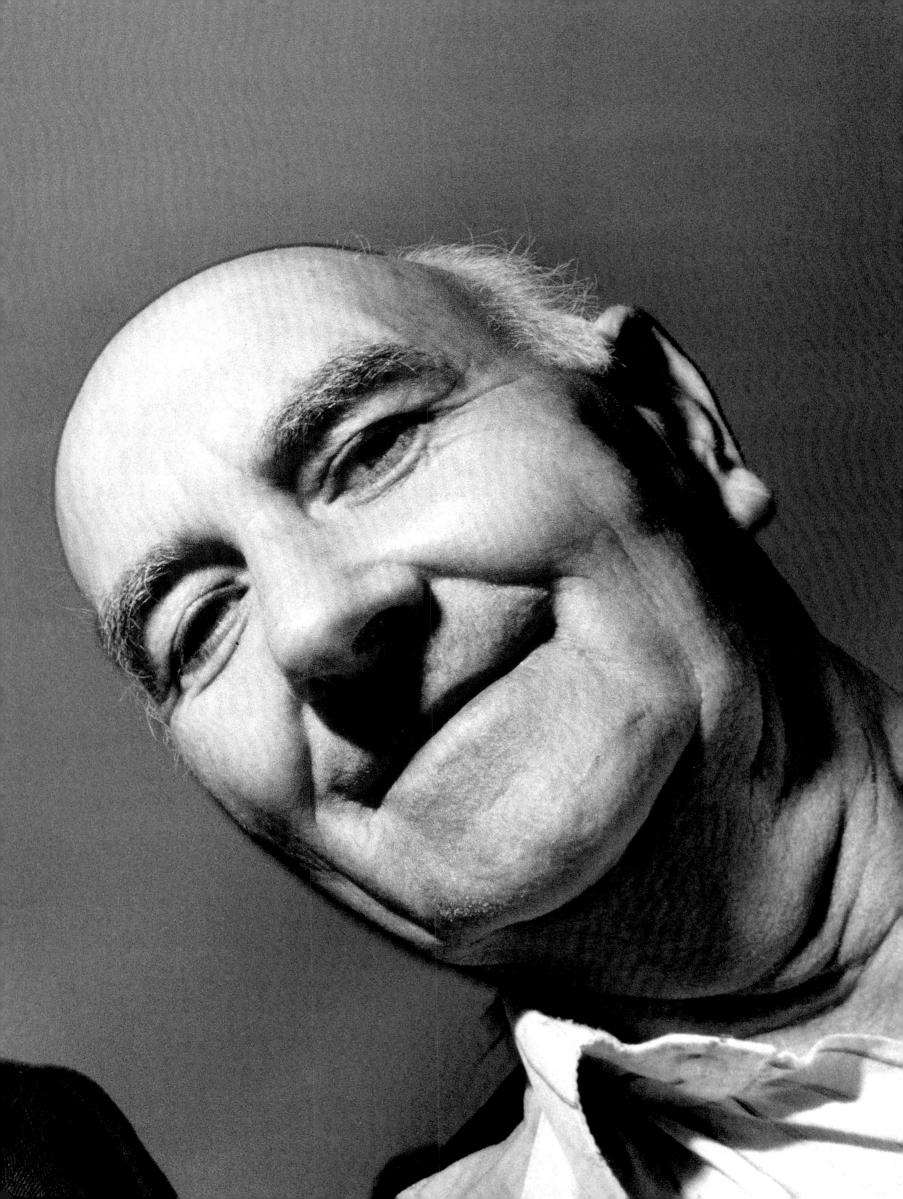

That's how it is.

How can you see someone that's not there.

That's no problem, said Murphy.

The French chef came in for a gin. When he heard German spoken he piped in.

The conversation continued on in French and German.

What are ye saying, asked Aggie.

We're talking about Ireland, said the chef.

Speaking of Ireland, said Murphy and he rose a finger.

Do you know the wonders of the world?

I do not think so, said the lad from East Germany.

Well this is them, he said. He got up and posed by the bar. Right. Are you with me?

The chef nodded.

Now. Murphy laughed to himself. Right. **Number one.** The foal of a ginnet. Yes?

The lad looked to chef. The chef rose his shoulders,

opened his hands outwards and sniffed.

You can never get a foal from a ginnet, explained Murphy, don't you know.

Oh, said the chef and he translated something into German.

Two. Number two. Right. The tops of the rushes green.

Ah.

They looked at each other in bewilderment.

The tops of the rushes green, right?

Right, said the chef.

Number three. A shoe to fit the foot of the mountain.

Yes indeed, a shoe to fit the foot of the mountain. Do you understand that?

No, I'm sorry, said the chef.

Never mind. **Number Four.** A blanket to cover the bed of the ocean.

He shook his head with merriment. The Germans smiled.

Tim-Pat looked into the far distance. Aggie rested.

Number Five, said Murphy, and he burst out laughing. Number Five, he repeated.

Go on, said Aggie.

A square arsehole, said Murphy and he sat content.

I understand the last one, said the chef and he said slan

and headed back to the Irish House. The market stalls were coming down.

The poker players got into a taxi. The banks closed. A solicitor

and his client stood on the steps of the courthouse arguing.

The man from the shirt stall tipped in quietly into Langs and went to the bar.

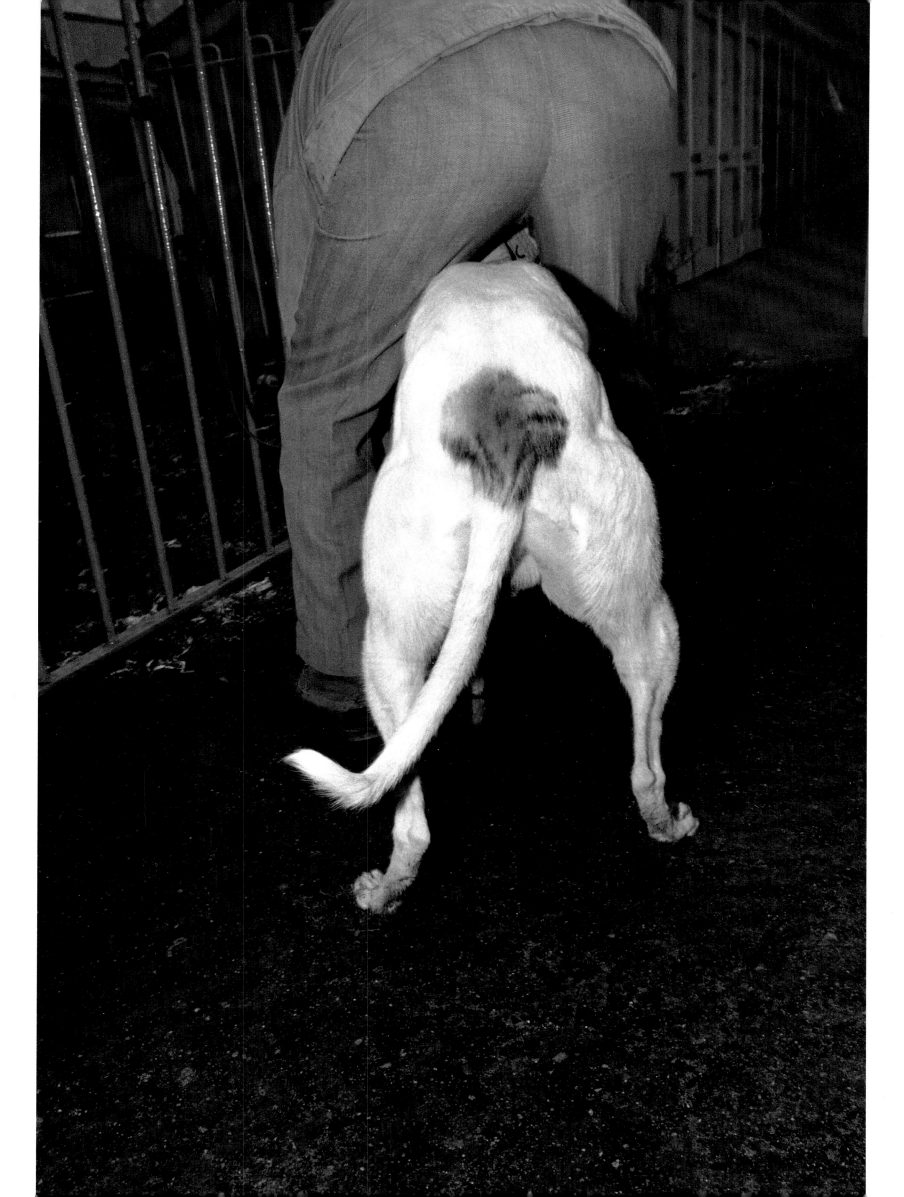

Mattie Sheridan, he said, has done a runner again.

No, said Aggie.

He has.

The dirty bastard.

I'll have a hot whiskey, he said.

Right, said Aggie.

And I'll have a cold one while I'm waiting.

He drank the Powers whiskey straight down, shook himself and bowed his head. He arrived back to where he was the night before—then he watched the kettle boil. He watched it for a long long time and was going to say No, he didn't want a **hot whiskey**. I'm fine thank you. Then it arrived. A lookey hung from his nose. He wiped his face with a hankerchief. He put the lemon aside. He smelt the cloves.

Bold Robert Emmett, he said to himself.

Jaimie on his way back from the toilet shyly stood by the Germans.

Do you play the music, he asked.

We are learning.

It's a lovely yoke. He lifted the bodhran.

Hit it for me, he said.

He handed it to one of the men who handed it to the woman. She crouched over the drum and scattered a roll.

Lovely, said Jaimie.

You play?

No, he said grinning, no.

Come back here, Jaimie, said his father. His son flew across, head-down. You know where we are going today?

I do, said Jaimie.

Do I have to tell you?

No.

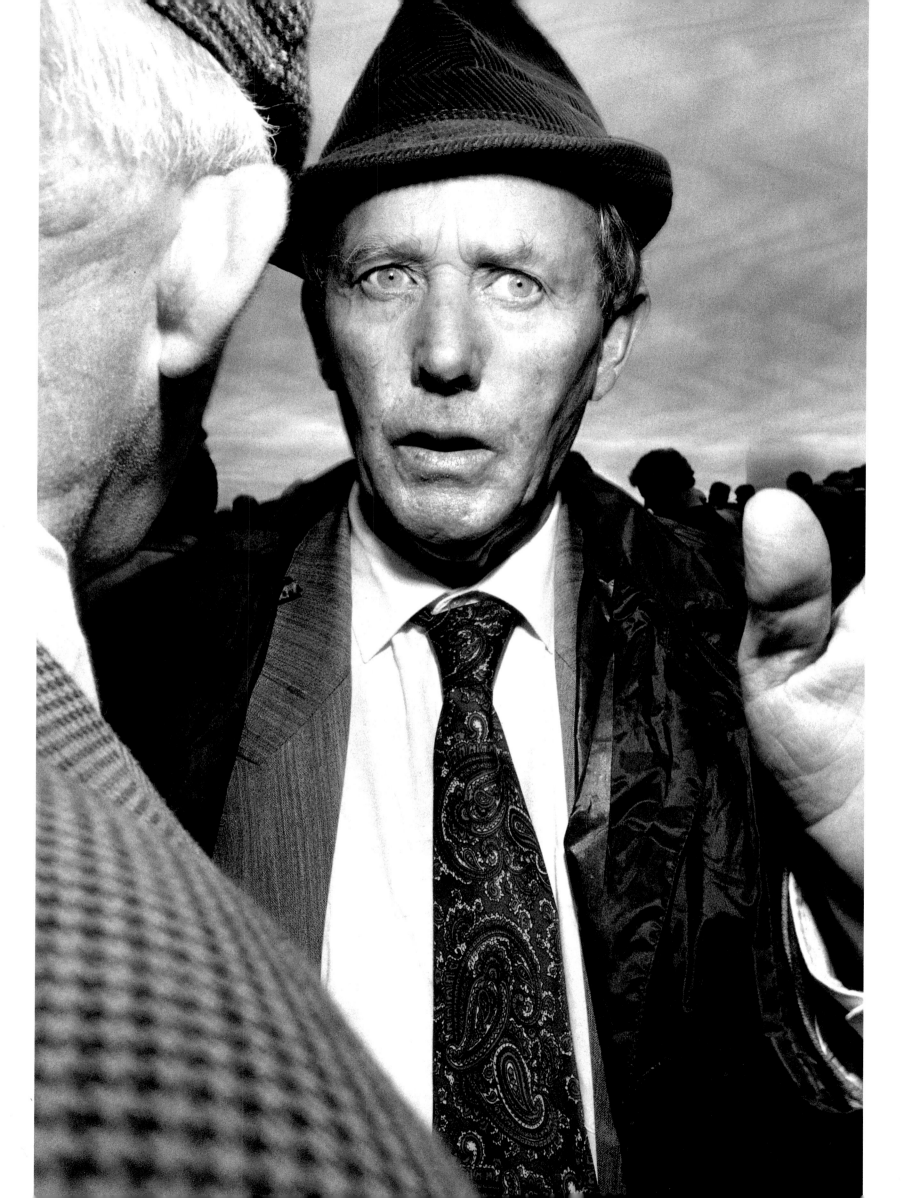

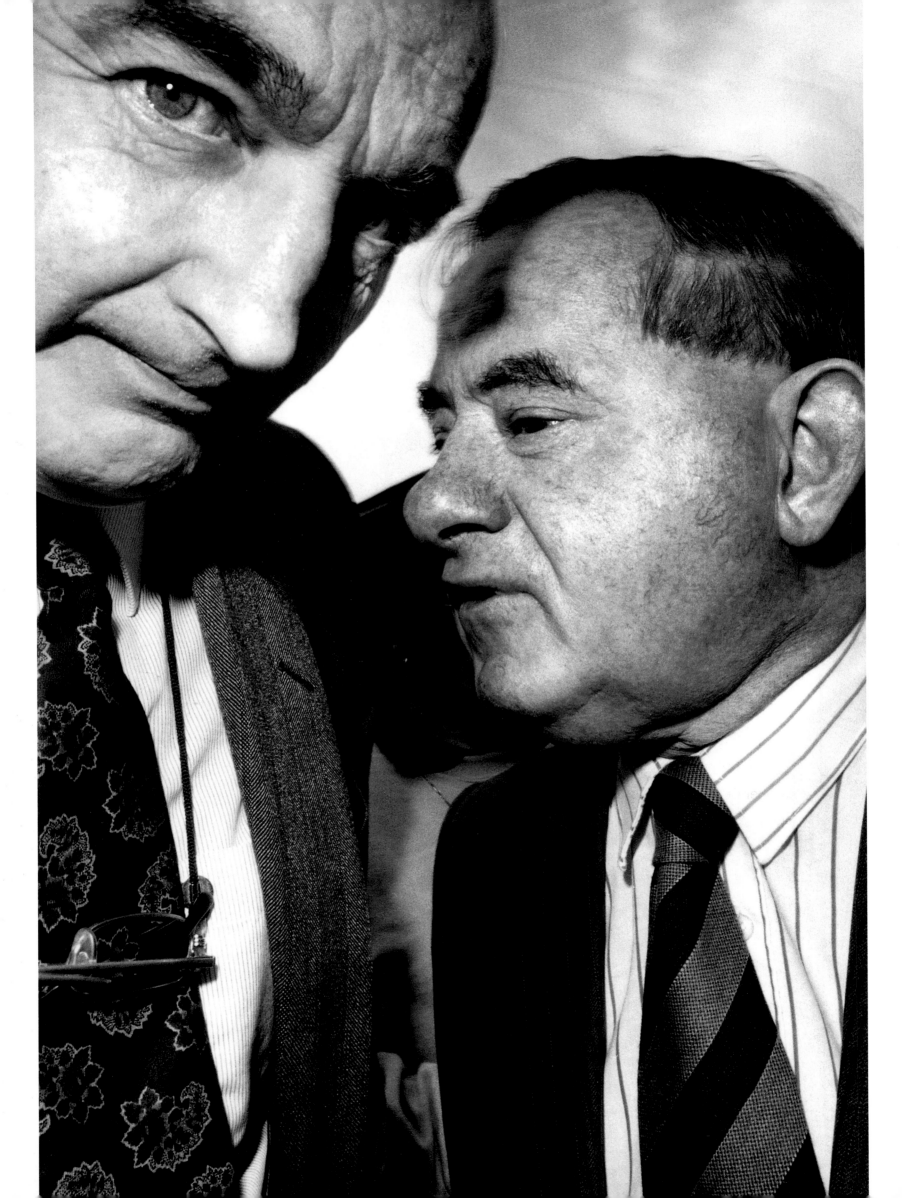

Say that again.

Ya!

So you don't own your houses at home in Germany.

Nine.

I want you to say it loud and clear for that man there. You do not own your houses.

No. We lease them.

There, you see, I told you. Are you listening ?

I'm listening, said Tim Pat. They said they lease them.

There you have it - we lost out language and they lost their homes. The German is homeless.

And he laughed.

Sit down, said Aggie, you're getting high.

We have everything under the sun here, daughter, said Murphy, shaking his shoulders and just at that moment the girl from Bavaria turned and snapped him. Blinded from the flash he shaded his eyes. The Mangans rose as one and left without a word.

They looked in passing at the German's jeep that was parked near the gate to the mart then continued on.

A Japanese job, said Hughie.

4 wheel, said Jaimie.

A new car in an old town makes an old town look bad, said the father. He climbed into the back of the van and sat into an armchair. A woman drew the door shut behind him.

The Germans left. The Germans were gone. **The gypsies were gone**. The stall holder ordered another hot whiskey. In came a couple for a glass of Baileys and a vodka and ice. He got on his mobile immediately and began a long conversation with George. It was George this and George that as he strolled to and fro along the counter while she sat thinking of something grave, that later became lighthearted.

Then young Sheridan came in and looked around.

How-is-your father, asked Tim Pat.

He's fine, he said.

He's tough, he said.

He is.

He is surely.

The lad left.

The phone calls continued.

When one ended her boyfriend rang another number but they were not at home. It was important. That they were not there made him listless. He wanted word. I'm too late, he said to her. Never mind, she said. I had to ring to get a tip, he explained to Tim Pat. He rang back again getting more and more anxious. He could not let go of whoever was not at home. She said they should be going.

I told you, he lamented, I told you.
Don't, she said.
If we had—

But she was gone. He went reluctantly leaving his glass unfinished. Very troubled in himself he stopped again on the street to ring but they were not at home. They were gone whoever they were.

Stay just where you are, said Murphy.
Why?
I want to admire myself in you.
That does it, said Tim Pat.
Easy man.
Easy my arse.
As you get older life gets trickier.
In other words?
Don't do anything too hasty.
So tell me this, said Tim Pat.
Yes.
You mentioned a ginnet earlier.
I did.
So what is a ginnet?
You know too fucking well.
Just tell me once again.
The ginnet is the offspring of a horse and an ass.
True. But which is the mare and which the stallion.
Which is the mare?
Aye.

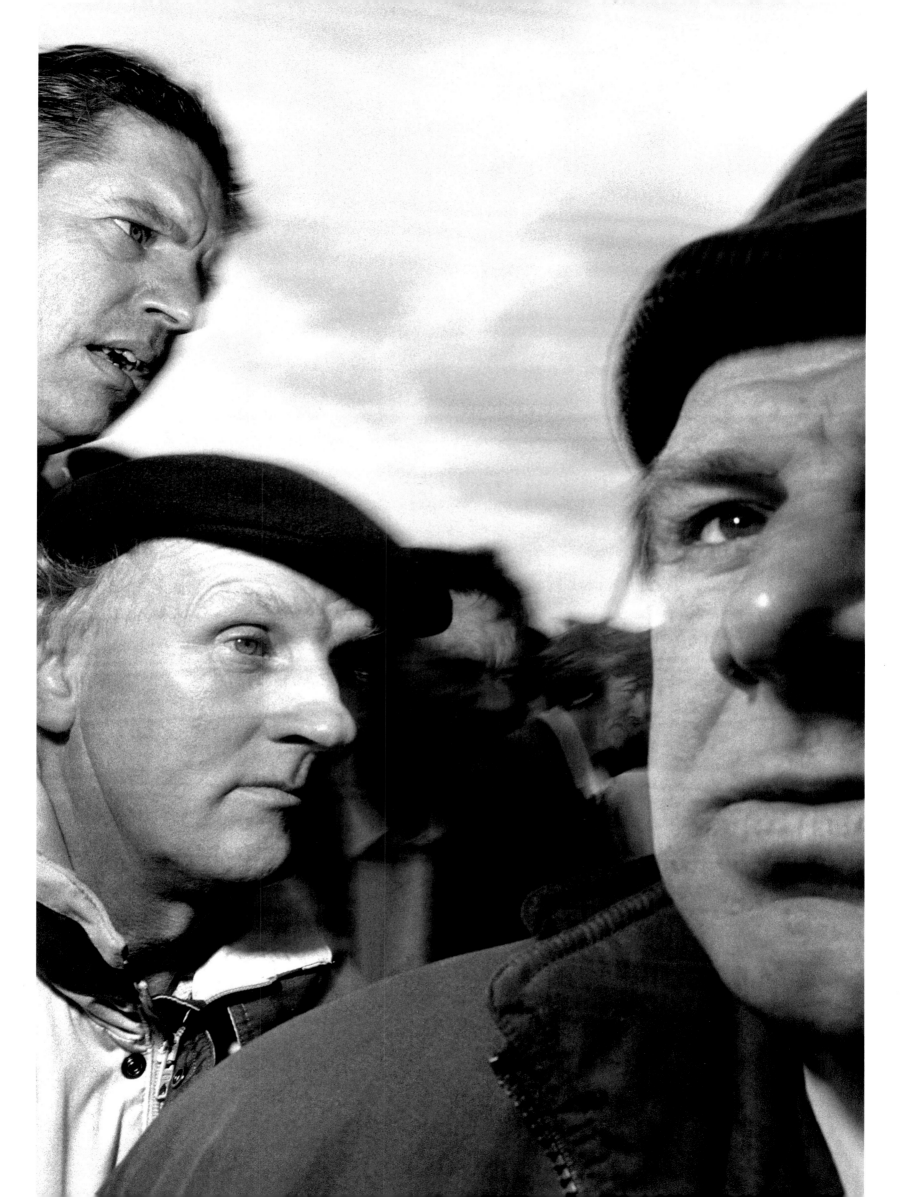

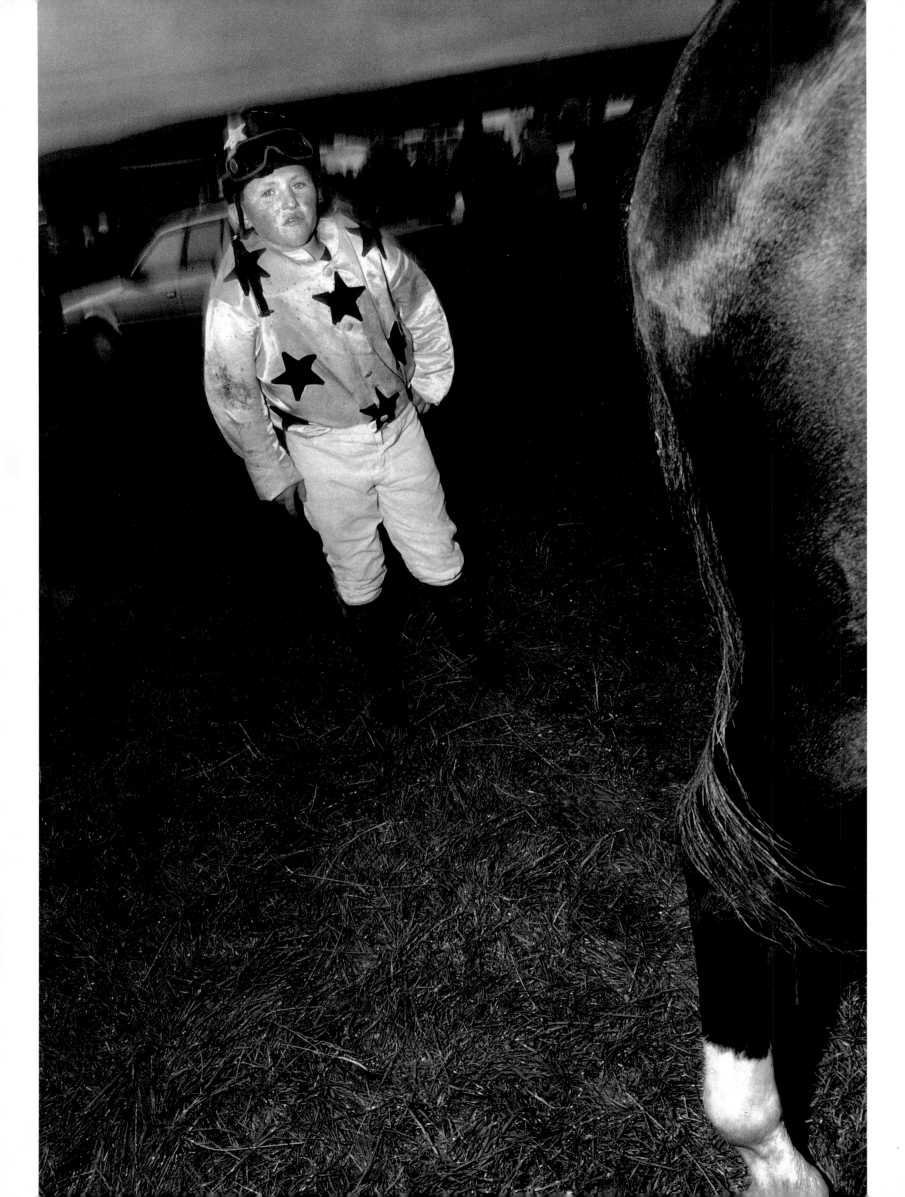

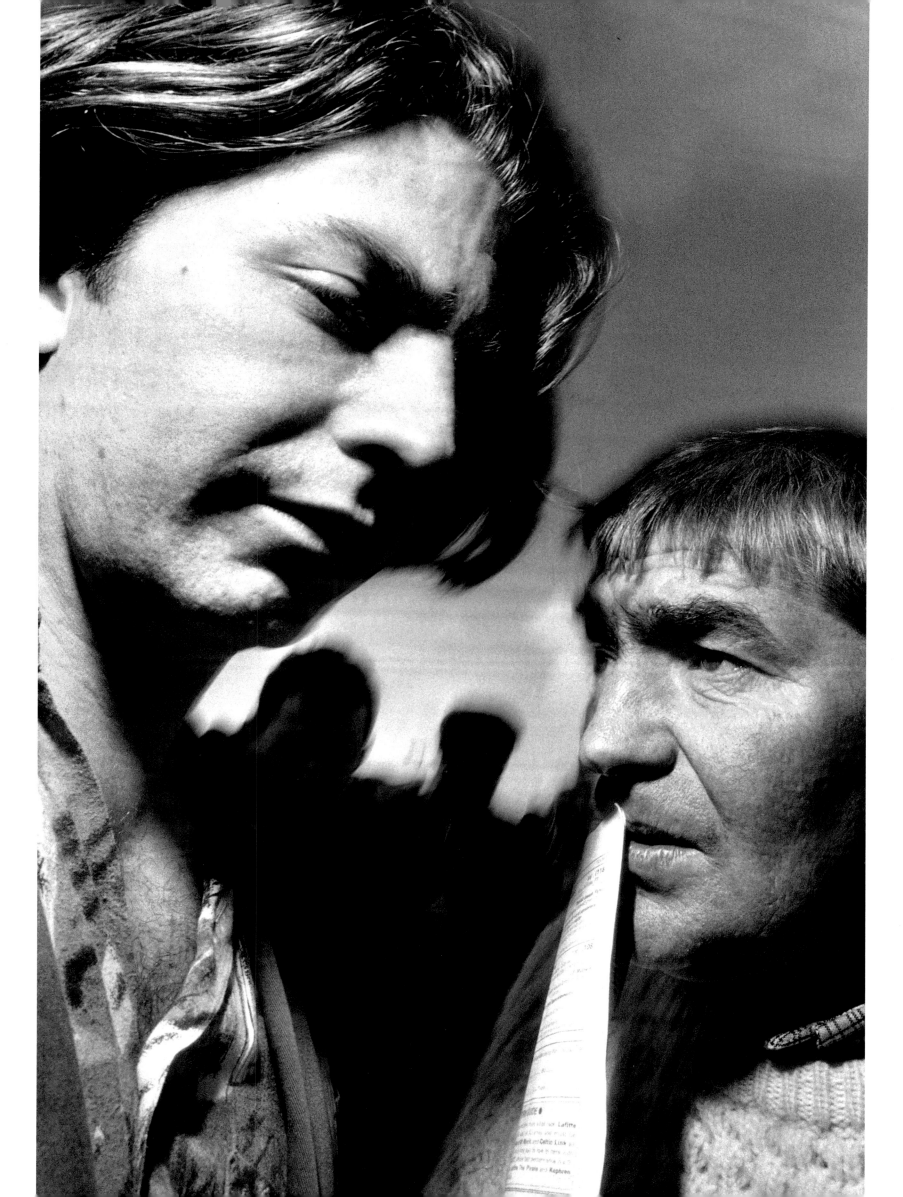

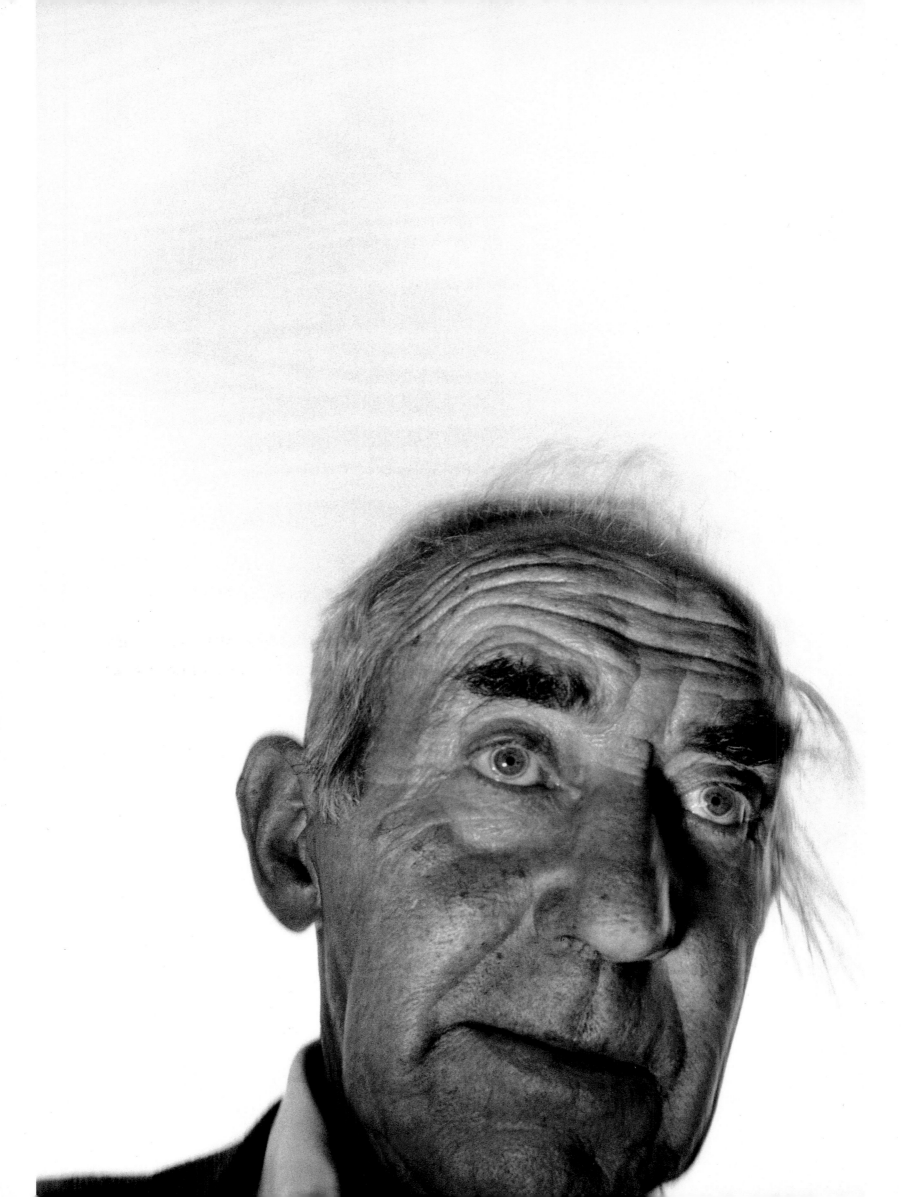

Murphy hesitated.

You asked me this before.

I did.

And did I get it right then?

No.

Do you know, he asked the stall-holder.

No.

Right. Right Mister Banks. He streached the fingers of his two hands round his sunken crown.

Don't tell me now.

I won't.

The ginnet - he said looking up - is the offspring of the ass mare and the horse stallion.

No.

No?

No. That's the mule.

It is not.

Is he the mule by God, said the stall-holder.

It's the ginnet, Aggie, am I right, said Murphy. Am I right?

It would make a dog think, she said.

And the planning officer was down the field testing for drainage. Wasn't he. **He was**. Yes.

Couldn't a fucking septic tank go anywhere in that field, dab and sand, that's what I say. Enough drainage to soak the shit of the county. He should be fucked in over the cliff. And the worst thing is the fucker is not from here.

He's not.

Drainage!

He has a job to do said Aggie.

So have we all.

They make plans.

Haven't we been making plans for centuries.

That's right, said the stall holder and he stood. That's what I should be doing right now.

Making plans.

Do Ivanhoe, said Tim Pat.

Do you think?

I do.

Well thank you kindly. If the last horse I did had not been beaten mine would have won.

Is that so.

It's so.

Young Sheridan looked into the bookies.

Is my father here? he asked.

No, said Mister Shields.

Was he in at all?

No son. I reckon he's stopped out at the course.

Oh.

He went across to Waters, looked in, searched the toilet, the yard, then he went across to The

Fluter's, all the same, no-one.

Are you going, asked Murphy.

I am, said Tim Pat. I'm off to do Ivanhoe.

Don't go.

I have to.

Why?

I can't take it any longer.

Suit yourself.

I will.

Look.

Look what!

Look at me.

I'm looking.

Did you do it?

I did not.

If you did just shake my hand. I won't hold it against you.

I won't shake your hand.

So you didn't do it.

No.

Right, said Murphy. Well shake my hand anyway.

No.

Why?

Because I didn't do it.

Ah Jazus Christ of almighty!

I'll be seeing you Peadar.

He pulled the door behind him. Murphy stood and watched him go
through the window. The town was closing down.

He sat back in his chair.

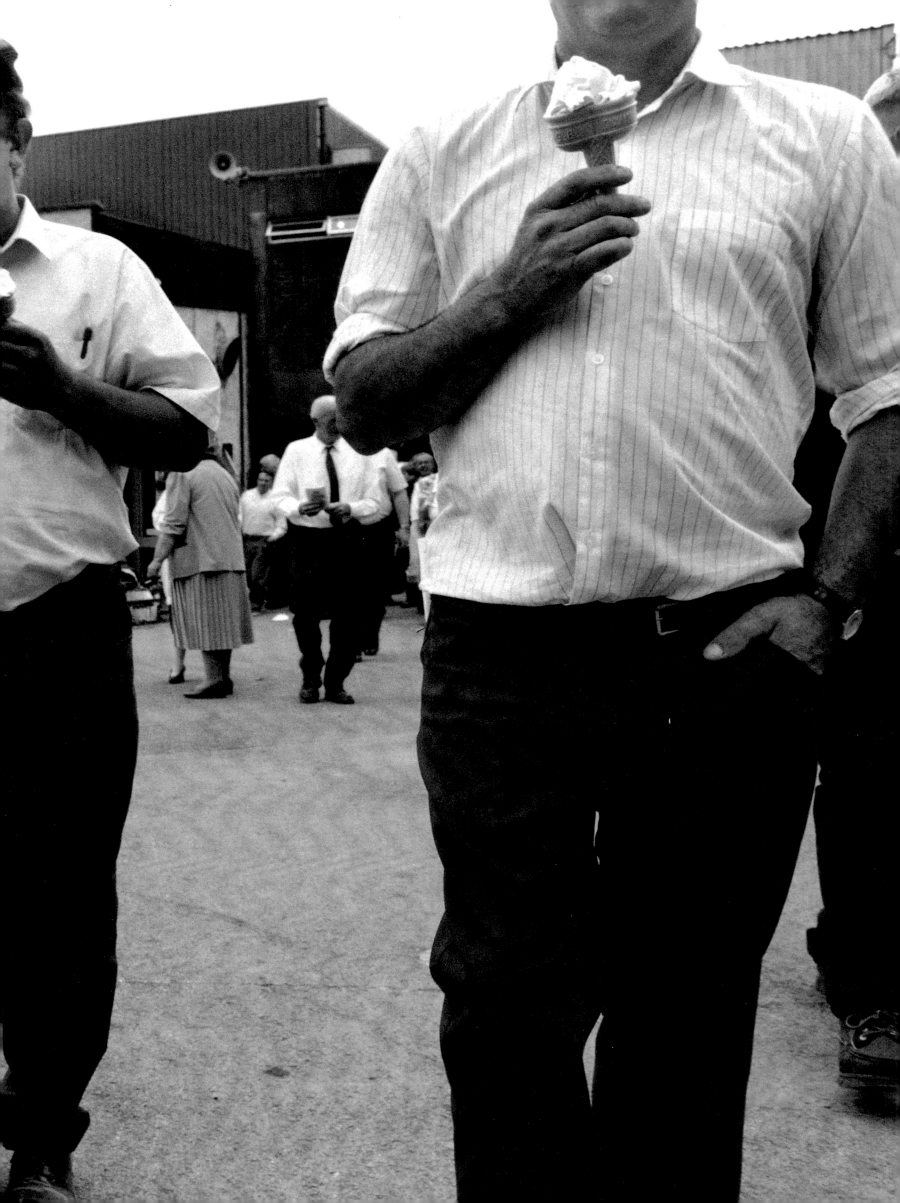

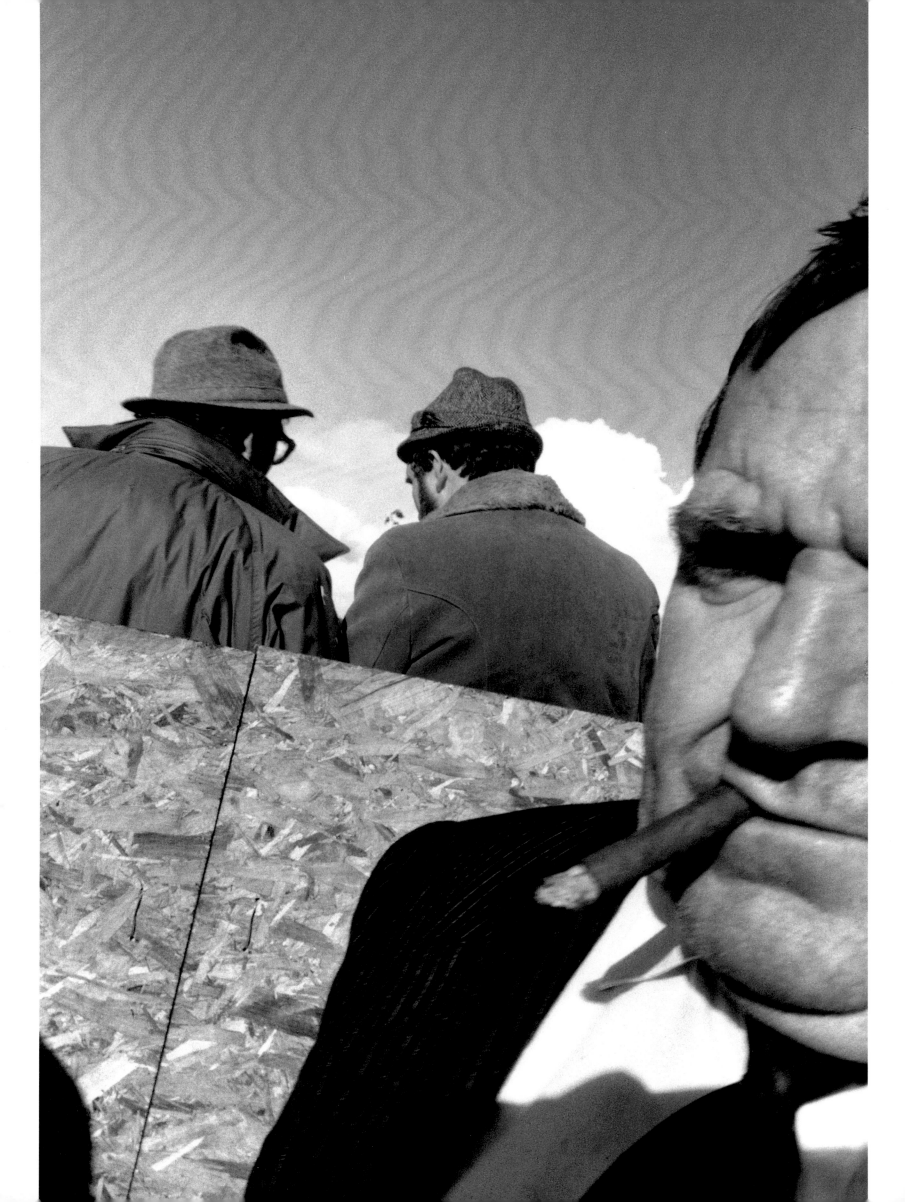

I wonder did Mr Mc Donald stop on the bridge, he said. You see, he always does.

Why, asked Aggie.

Superstition, said Murphy, that's why. And that's why I like him. But that man who was standing just there is another question entirely. He has deep-down problems, he has.

You're too hard on him.

Maybe.

So what's your problem with him?

He likes to be liked.

So do we all.

True. **We all like to be liked.**

So?

But not by the wrong people.

Aggie drew out the drawer of the till then slammed it shut. She looked into the Harp mirror and blinked.

The sea was cracking last night, she said.

It's the frost makes the sea rise, he said, suddenly clear eyed.

Ah.

And the moon is on it's back, God help her.

Ah.

And Jimmy's gone.

Aggie sighed with a whistle. Murphy threw a hand in the air. She tapped the counter with her knuckles. She threw her eyes to heaven. He let his chin fall onto his chest.

Stones, he said, fucking stones.

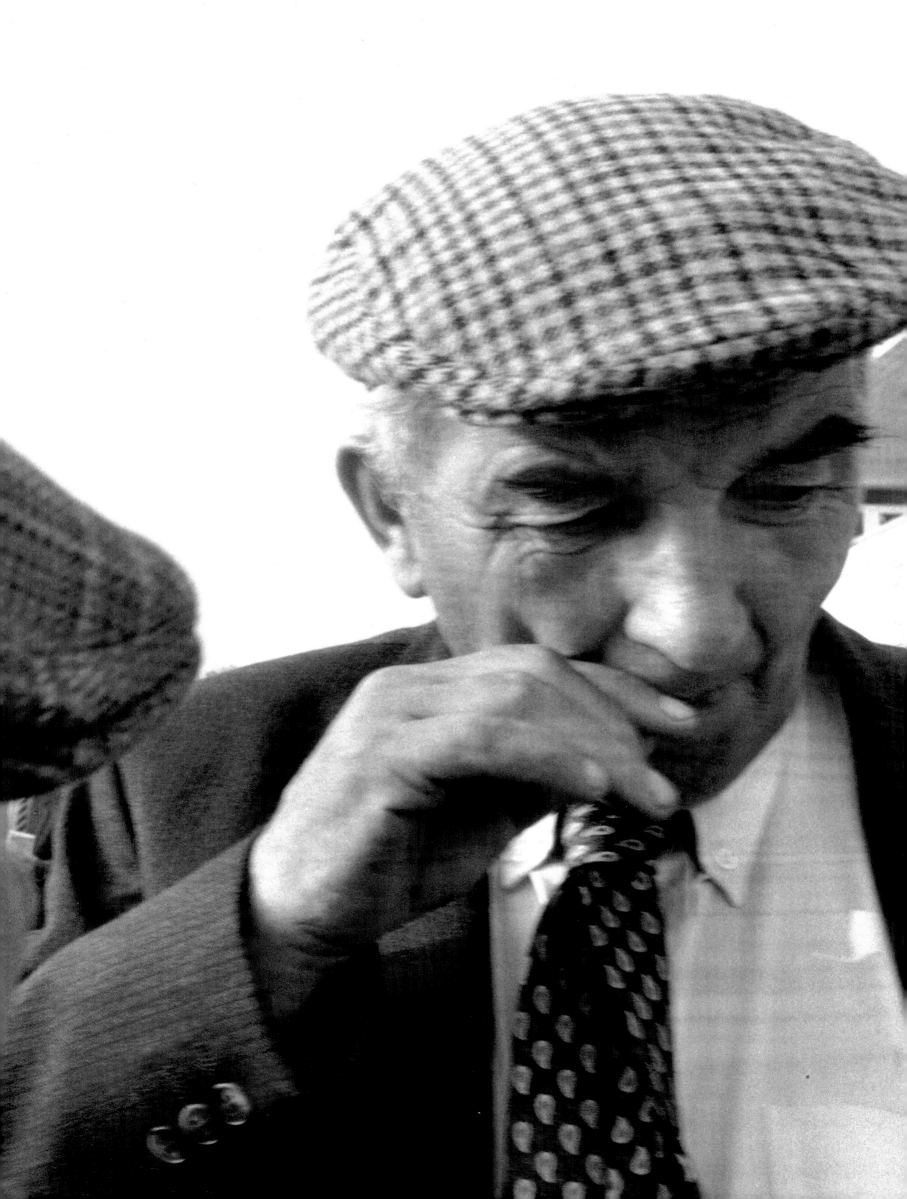

We'd left Coolaney in the van in the early evening, **the lights on dim**, maybe three in front and two boys behind.

We were on our way to the horse fair after coming the night before from Dowra mart and then I took this corner, nice and easy, maybe **two or three bottles of stout** that morning with Mattie, nothing else, slept well the night before in lodgings though what I dreamt I couldn't say and had a midlin breakfast, no pressure, just chatting away about the gypsies we'd seen that morning leaving town for the fair when the next thing was we were on a rise in the middle of a field, a stony field with the sea in the distance, lapping, flat calm, we'd gone off the road onto some sort of lane, you could say we were going up an old track, so I slid to a stop and left the hand brake on and got out to see what was going on, what's going on, Mattie Sheridan called, Are we stuck, asked another voice, I've gone wrong, I said, It would take you came the reply, and the others, all men I knew well, climbed out from the front and then from the back, and stood around laughing and looking, and there we were in a field of rock smothered in lichen and gorse blooming on the incline, so what could you say, Petey lit up and I went back on foot the way we'd come to find the gate, **Stop where youse are** I said, and they shook their heads like, darkness falling but I could make out their shapes in the light of the van, and I headed off down the incline seeing nothing but keeping my eyes on the ground so that I'd stay on the track, and I was walking maybe ten minutes, but was there a gate? there was no gate, I struck a match but no sign of a gate at all, and I said fuck this for a lark and I roared back up to them I can't find no gate, I shouted I can't find no gate! but you guessed it no answer, not in the earthly, there was no-one behind me, and I went back as far as I could calling out every few yards, and when I'd turn this way and that way I thought I'd make them out but there wasn't a soul, I went back up but was there a van? There was no van, and as for the men, there was no men.
I called again.
No answer.
I had on I thought a suit but now I found this coldness on my chest. I looked down. I was in my birthday suit. And my legs seemed awful long. And the worst thing of all was that my two arms seemed gone. **My eyes could see no arms**. Maybe they were smothered. The place lit up. Then the Japanese came, about twenty soldiers, each man struggling as if in mud, and some had guns and some had not, but most had water cans and they spilled by me as if I wasn't there. **Then came the Eskimos**, all in fur, breathing heavy, as if they had climbed a great cold height, and they went by me. The last of the foreigners were the Spanish, going one behind the other, in old armour and pushing through to the way ahead with their arms as if they were in a jungle. They rattled off into the dark.

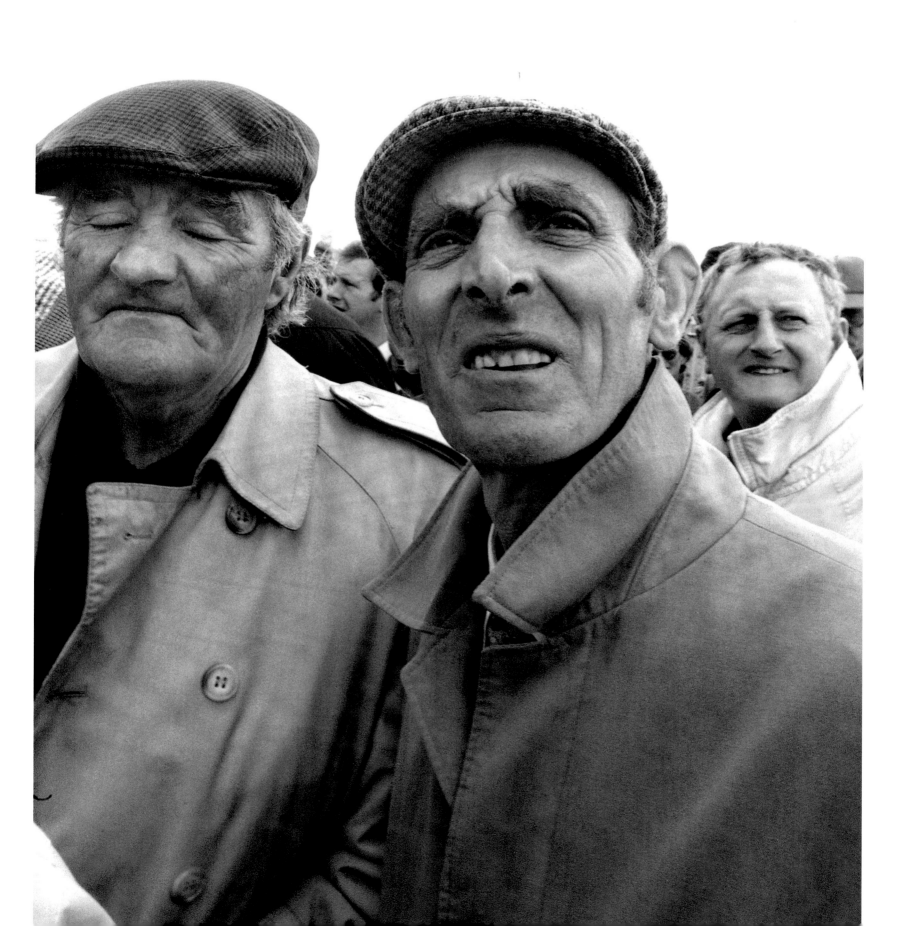

A long time, nothing.

And then it started.

Horses, nothing but horses, coming up the rise, whinnying and galloping, there must have been hundreds, many hands high and each one was drawing a wheel chair with no-one in it. This could have gone for hours. Like some funeral. And the horses were still there when the four grey donkeys appeared, each coming very slowly, and I saw they had baskets on their backs and in the baskets were these birds, young pheasants, polts, and the asses came to stop in front of me and they got down very gently onto their knees and the birds tipped out onto the ground with a screech. One rose and landed on the crown of my head. **I could fell his claws digging into my skull**.

He was a great weight and I was giving in under his weight. I couldn't shake him off.
My eyes were closing with the burden of the bird when suddenly off she flew. I was on my hunkers on the ground without my arms. A small trickle of blood coursed down my forehead. I lifted my head to shake it out of my eyes. One donkey came close. He put his snout next to my forehead and breathed me in. His lips were wet. I looked into his eyes. He drew back and whispered. The birds landed back into the baskets—then the other three asses rose and whispered. All four asses began whispering. In this way they left.

Only a distant screech from a polt then nothing.

I sat on the earth.

I was sorry the beasts were gone. Even if I had made them up at least they were there. With their empty wheelchairs and their bird baskets. Now there wasn't a sound. It was like I had heard some awful news. News of the worst kind. I stayed there like that. I was not interested in anything any longer.

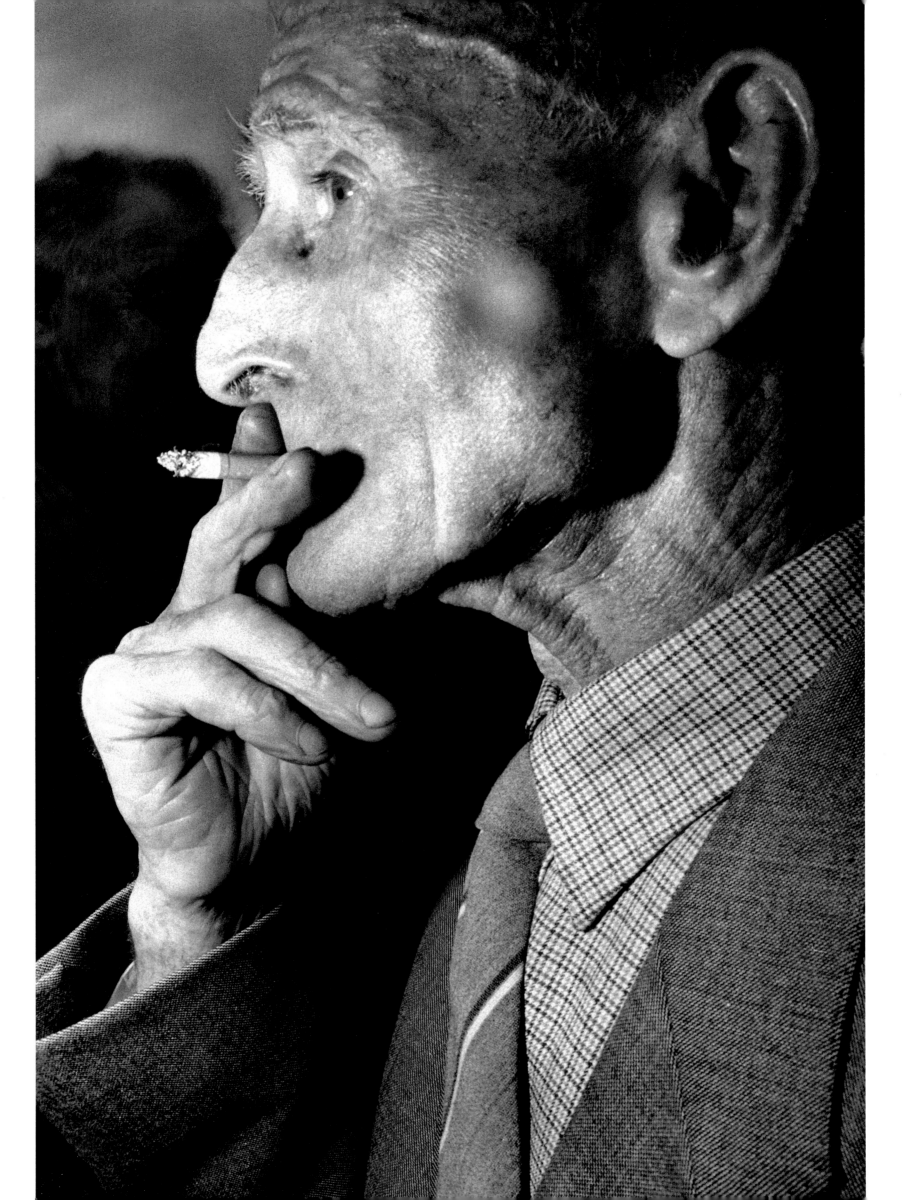

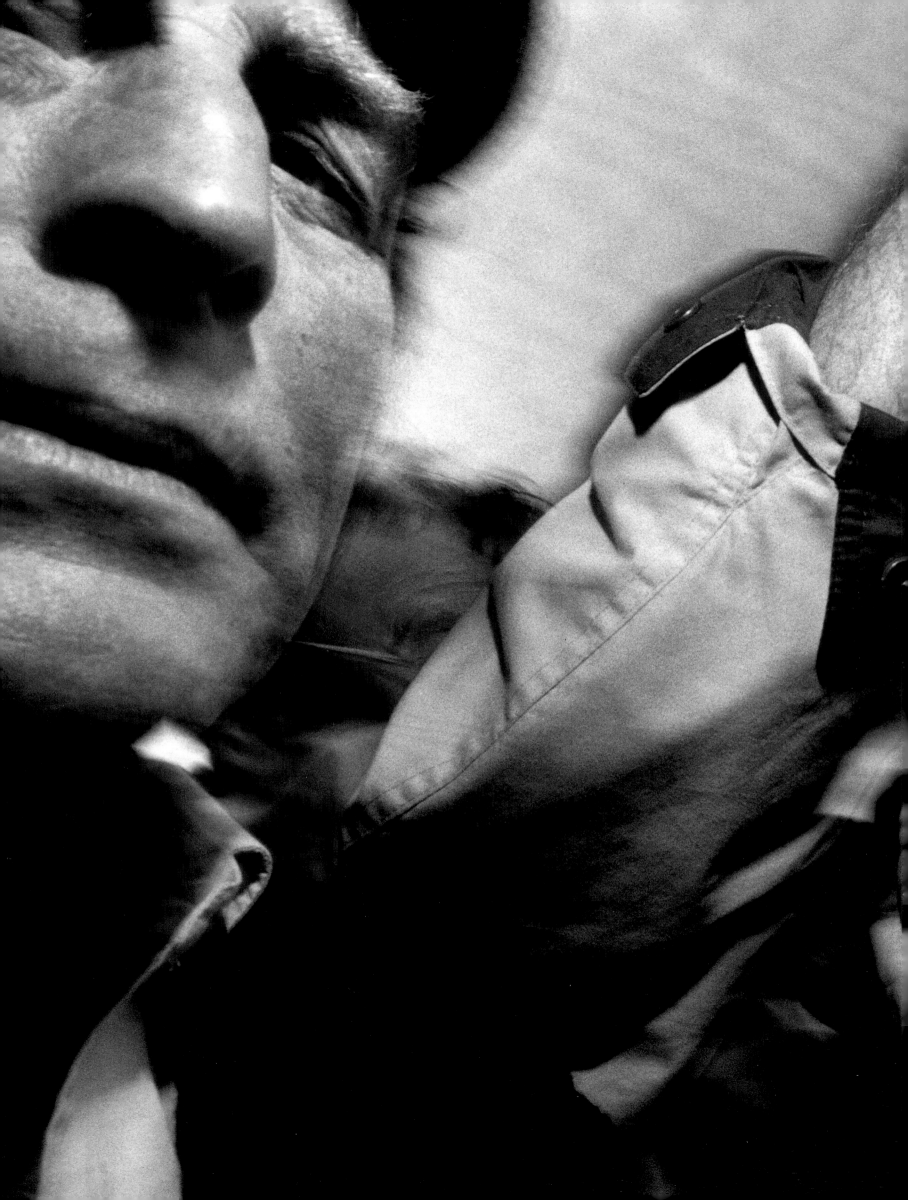

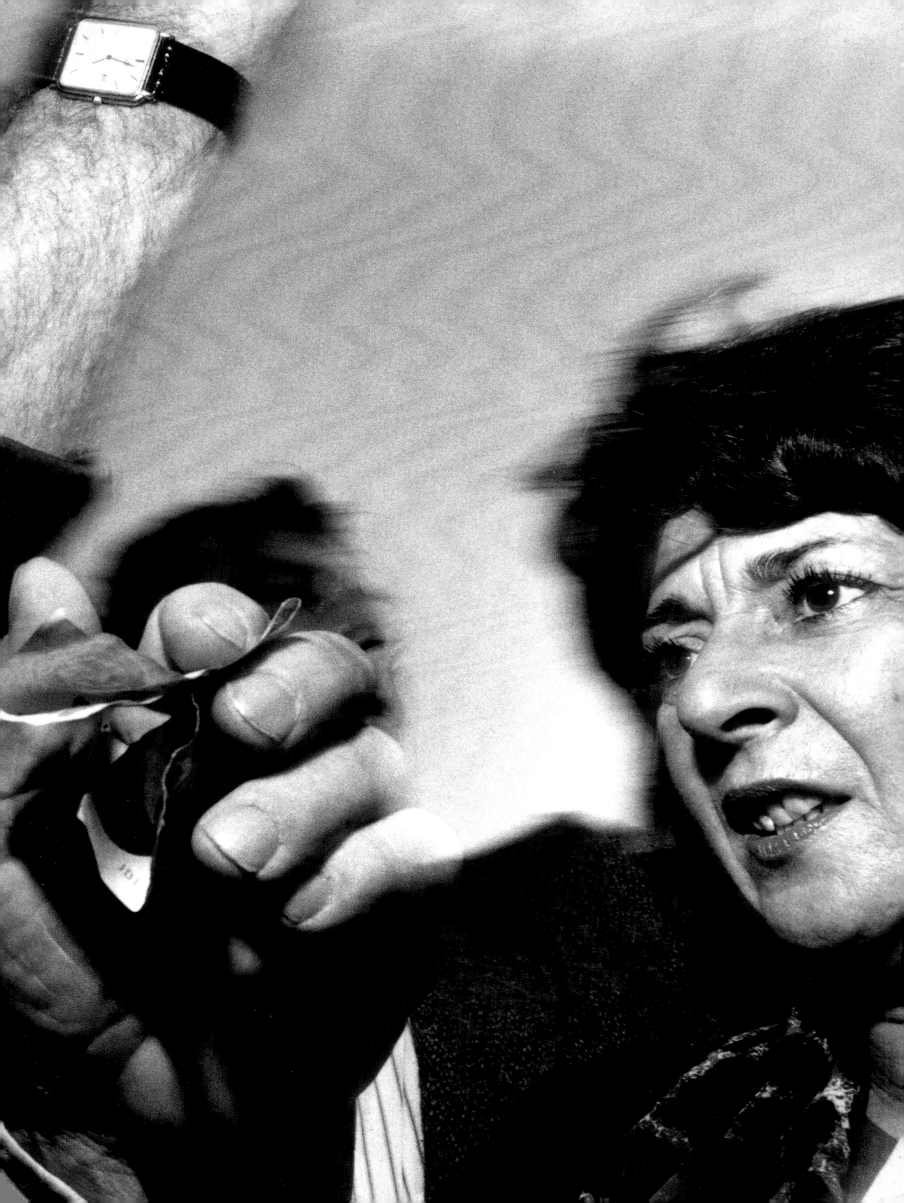

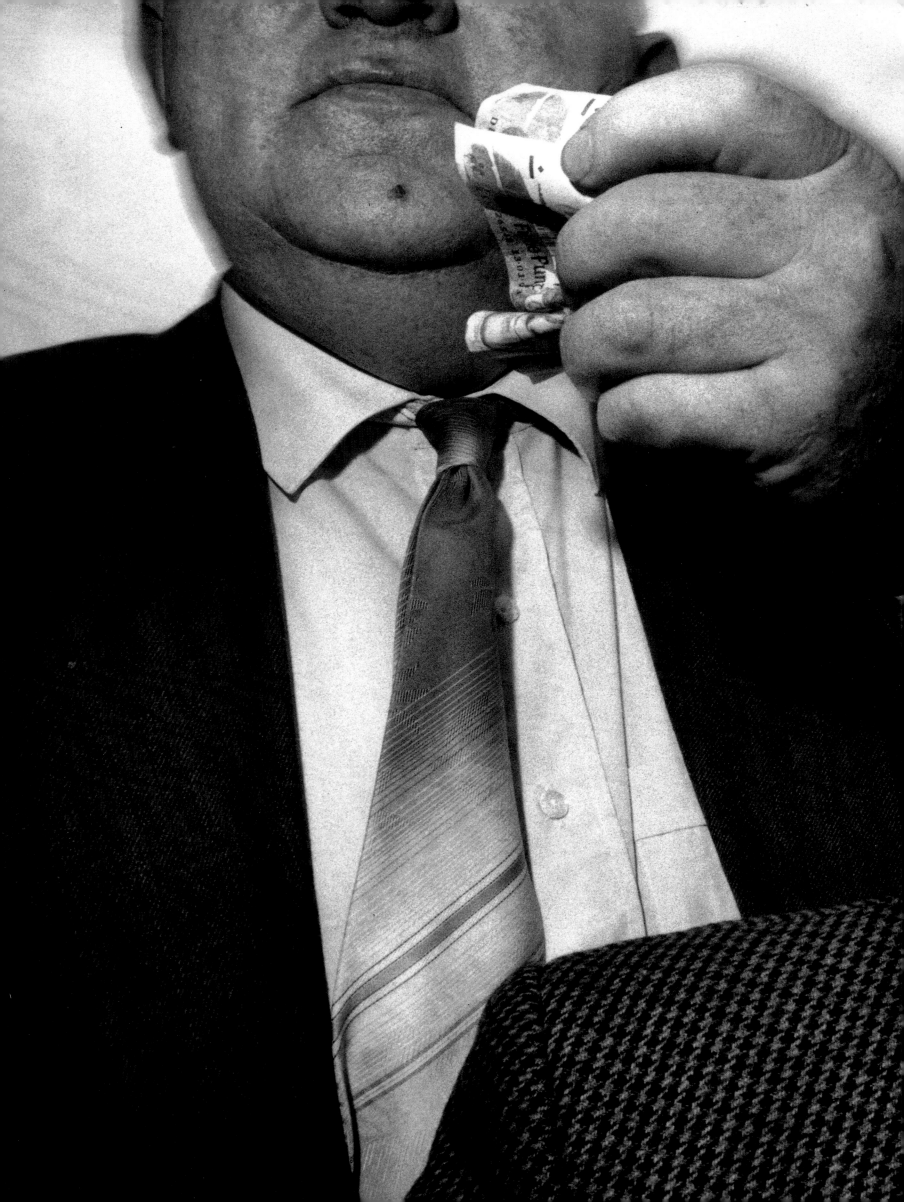

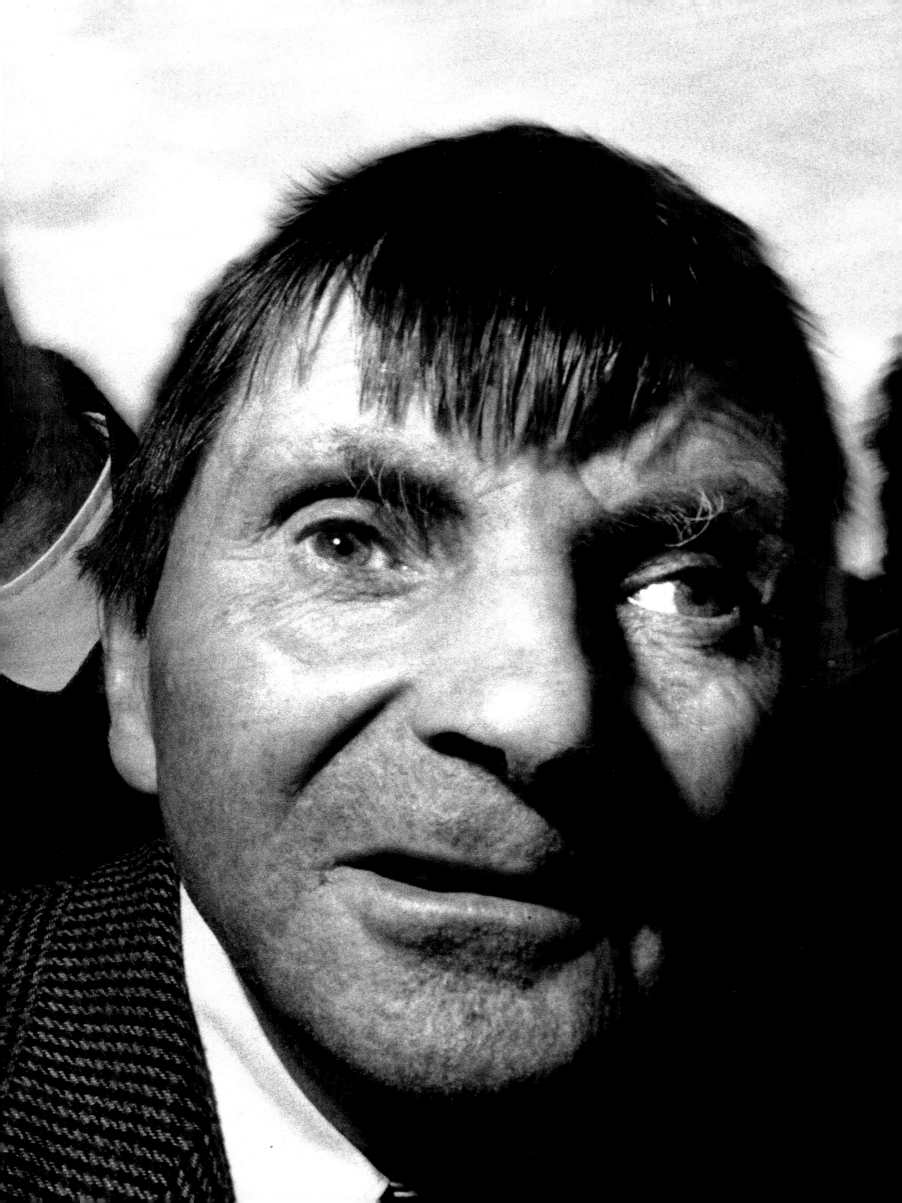

Yes? said Aggie.

What?

You were saying?

Nothing, said Murphy. Nothing. He rose his glass—to the ring road!

Ahoy!

And all the small towns in built up areas.

Fair deuce, chirped Aggie.

A farmer from Northern Ireland stepped out

of a BMW, tipped through the door in high boots, ordered a pint

and sat where the gypsies had been.

Does he look like an owner? whispered Murphy.

How would I know, said Aggie

Murphy walked to his table.

Are you for the races?

I am.

I thought so. He tipped his skull knowingly. I knew it.

And you?

I might, and I might not. If I do I'll see you there. If I don't I won't.

Do you mind if I sit?

Sit away.

Have you anything running?

I might.

Whisper?

Corgie in the second.

Corgie?

Corgie.

Right, said Murphy. He stood. You know they're killing all the rabbits,

he said and he bowed.

Are they?

They are. Certainly.

He left down his drink.

I think I'll go before the off, he said.

Then he left. The dog at the monument followed him. Aggie arrived with the stranger's drink.

Who's your man? he asked.

Murphy, she said, is his name. Then she went to the window to follow his path.

He'd be high and when he is there's no talking to him.

He had the look, agreed the stranger.

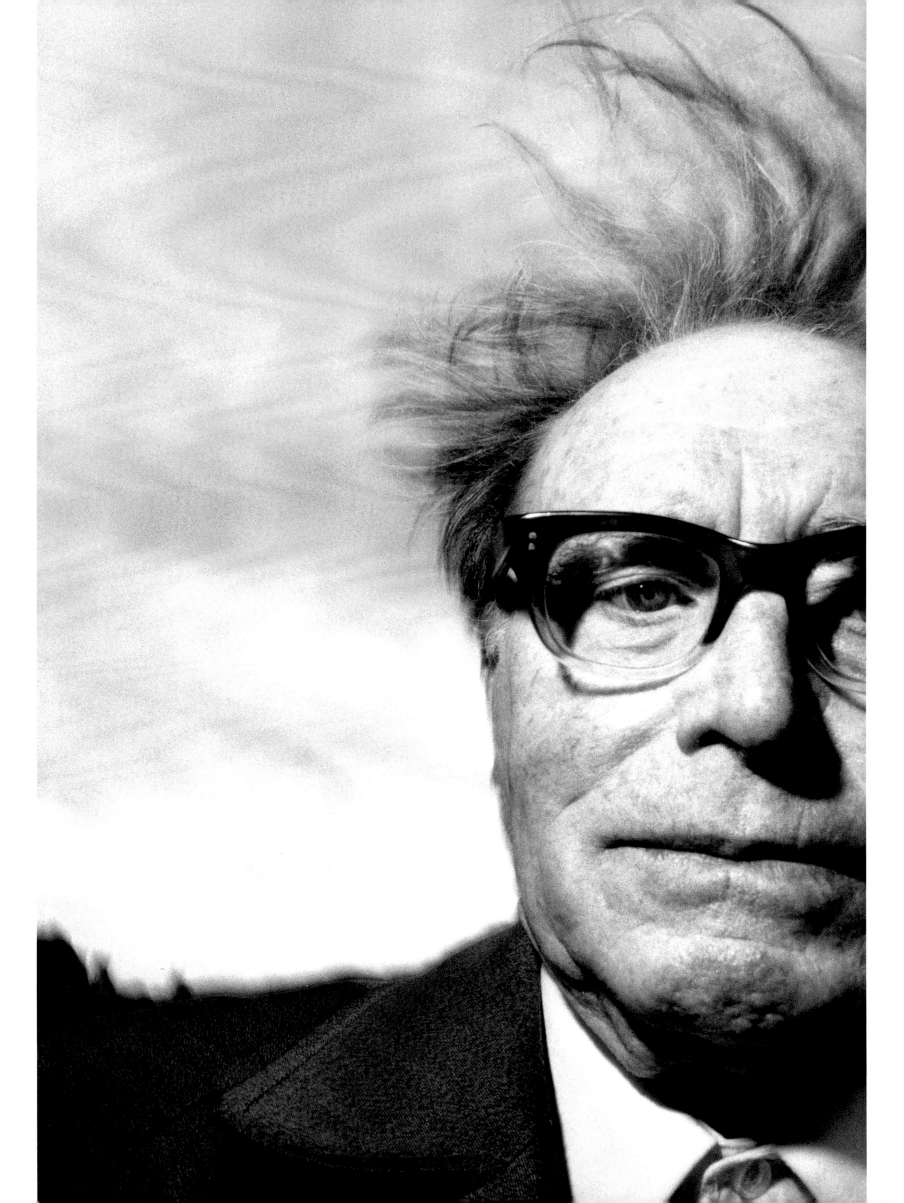

To Sophie and Nina

First published in 1999 by

Dewi Lewis Publishing

8 Broomfield Road

Heaton Moor

Stockport SK4 4ND

England

0161 442 9450

Copyright © 1999

For the photographs Bruce Gilden

For the text Dermot Healy

For this edition Dewi Lewis Publishing

ISBN: 1-899235-17-5

Prints by Yetish

Design Associate, Kristi Norgaard

Printed in Italy by EBS, Verona

Special thanks to,

Christine Redmond and the Gallery of Photography in Dublin; Paul Redmond;

Betty O'Connell and the Irish Race Association; George Bryan

DESIGN BY YOLANDA CUOMO / NYC